THE FUTURE

of

Professional

PHOTOGRAPHY

&

Photo

EDUCATION

N. David King

ISBN: 978-1-387-35713-0

FOREWORD

This document represents my own personal experience and knowledge of my field of commercial photography, and my own research into the incredible variety of influences impacting that field and its future. It is written initially to help inform our plans, decisions, and requests as we seek to improve our program of professional photography at San Diego City College. But perhaps it can help other programs as well.

I make no claims that my research has exhausted all the possible areas of influence at play in this incredible complex modern world though I have tried to cover the major ones. The caveat must be that even the limited influences I've examined form such a convoluted web of connections that my conclusions are almost certainly not the only ones that could be drawn from them. Nevertheless, it is my firm conviction that this document accurately sets forth the trends that are now happening and will be happening in the next 5-10 years barring something unforeseen appearing on the scene (imagine that...).

But prophesy in the face of complex technical considerations is a risky business fraught with unseen and unforeseeable variables. When we look back from the perspective of those 5-10 years down the road, we may be forced to agree with that great sage, Yogi Berra, who was credited with opining that, "The future is not what it used to be."

For photo educators this is a critical time because we are charged with accepting students and then promising them that when they complete our courses they will have the knowledge and skill sets that will enable them to work successfully in the profession. Given the nearly perfect collection of storms swirling around our world, that is a very

tall order. Indeed, it is my perception that we are already well behind that curve.

I believe that we as a program, and those authorities above us and upon which we rely for support, must act swiftly and decisively if we are going to be able to continue to deliver relevant photo education to our future students. This document, which pulls no punches and is not shy about pointing out what I see as roadblocks to that objective is designed to kick start a critically important discussion between, faculty, program advisors, and administrators to explore what we can do to address and meet the challenges coming at us.

I'd also like to express a special thanks to Tony Amat from NelsonPhoto and R3 Productions, San Diego, CA, for helping to identify and access industry resources to make much of the research for this document possible. Without his help this would have been a much longer process.

I would also like to sincerely thank Dr. Ricky Shabazz, President of San Diego City College, for his encouragement and support in creating this document.

N. David King, 11/2017

The
FUTURE of PROFESSIONAL PHOTOGRAPHY and PHOTO EDUCATION
by N. David King

TABLE OF CONTENTS

PREFACE

This document has been created to fulfill the requirements of a sabbatical leave granted the author for Fall Semester, 2017 by San Diego City College to provide the time to properly research and analyze a growing threat to vocational programs in general and our photo program specifically that is flowing, in part, from a 'perfect storm' in the form of a growing disconnect between the world of professional photography and the world of academia and secondary education, and the technology driven information-age world that is the environment of our students and potential students.

Finding a solution to calming the waters of this storm of existential threats to the future of photographic education was made even more difficult by the acceleration of complex influences impacting the world into which we were allegedly preparing students to enter. Despite our naturally human desire for simple answers, the various "worlds" swirling around us had conspired to thwart such simplistic efforts and were demanding a more complex, perhaps painful (to all) set of solutions because we had let it go so far before a proper appraisal.

I am from Colorado and spent most of my younger days exploring the backcountry, a place filled with situations and denizens that would happily end your days on the spot. An "adventure" was what resulted from a failure of planning. When you suddenly found yourself in the midst of an 'adventure' the common practice was to STOP and give it what a dear friend called "The 30-

Second Stare." That was a time of calm reflection and analysis to calm your nerves, subdue your fear and discomfort, identify the problem and propose a solution involving the least amount of risk. After all, you can't solve a problem until you admit it exists and identify it.

Growing up on a ranch I often heard the old timers say, "When you find yourself in a hole, the first thing to do is to stop digging." But the habit of digging becomes comfortable in and of itself, and our normal solution here in academia is instead of stopping the digging, to request the funds to purchase a back hoe to help us create a deeper and more perfect hole.

This document is my own attempt to define what I see as a major crux point in the future approach, and perhaps *existence*, of education designed to train professional commercial photographers, that 30-second stare. And, in doing so, to offer a way to throw away our shovels and start to fill in the hole... or at least climb out of it before the walls collapse on us.

The solutions presented here are discipline and program specific. The identified problems and influences that are negative to us may have no effect, or perhaps even a positive effect on other programs. But they are killing us and need to be addressed and solved as quickly as possible.

If our goal – turning out successful practitioners in the world of professional, commercial photo-based image making -- has continuing value (and since the commercial use of images is *growing* I believe it does) then it is in the interest of everyone involved to help us

find and implement a solution while we can and before we become irrelevant.

This is a time for frank, honest discussion without concern over any issues other than success. Personalities and turf have no place here because they cloud the real issues. The educational faculty, the programs, the schools, the districts, the State, and certainly the students all have a vested interest in our success.

INTRODUCTION

The world of photography, at least insofar as its technical underpinnings are concerned, remained little changed from its inception in the early 1800s until the late 20th century. There were, of course, advances in materials and chemicals and optics, brand names came on the scene, flourished, then faded away as styles and, sadly, management talents, failed their potentials. But despite a lot of "action" on the surface, there was very little modification to the basic workflow.

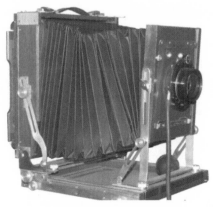

Here is a wonderful Deardorff 8x10 camera, the pinnacle of its technology in its day. Larger cameras were also used before the invention of enlargers to make big prints, but most cameras, going back to the mid 1800s, except specialty portrait cameras, were configured like this, i.e. what modernly we would call a "field camera."

The photographers who used this beast of a camera around the turn of the 20th century could never have envisioned this tiny little camera to the right – a Minox™ miniature camera 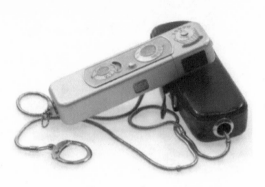 popularized in spy stories since it was in fact a useful tool of that tradecraft in the 1950s and 60s.

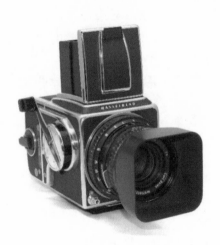

Nor would the intrepid photographers going into the field carrying glass plates in paniers on mules have envisioned a wonderful medium format camera such as used by fashion, portrait, and product shooters from the late 1940s up into the early parts of the 21st century.

This creation of Victor Hasselblad (on the left) and similar cameras by Bronica, Rolleiflex, then Mamiya and Yashica to name a few, were to become the workhorse tools of professional photographers of all types.

I'm showing you these cameras because despite their apparent and obvious surface differences, the underpinnings of all of them, the image capture technology for the working professional using them, has

remained essentially the same from the days of the Deardorff to the days of the Hasselblad.

Photons of light emanating from the sun or some artificial light were reflected from the subject into the camera's lens where it was refracted and focused onto a surface containing light sensitive metallic halides suspended in a gel-like emulsion.

And that meant that all cameras, no matter the type, size, or format, had to have the exact same set of controls for aperture, shutter speed, and focus to set the camera to make a proper exposure in order to create a good, workable photograph. The only difference was in where the controls were located

Once the image was captured and existing in potential in the light sensitive emulsion, it was, regardless of size or film brand or type, processed more or less identically. A lab in New York operated the same as a lab in Los Angeles... or London or Paris.

This was wonderful for photographers and for photo educators as well. The underlying reality was that if you learn one of them then for all practical purposes, you have learned them all.

The relatively standardized workflow consisted of an alkaline developer to turn the exposed grains dark, a rinse or quick acid bath to stop the action of the developer, and a fixing bath to remove all unexposed and undeveloped grains and stabilize the image making it light safe. A final wash to remove all of the residual chemicals completed the mandatory steps.

Needing only to familiarize him or herself with the specific chemicals involved and timing required, a photographer from 1900 would have no trouble operating a camera and making photographs in 2000.

Likewise, photo education was stable, meaning the topics and procedures had minimal, if any, changes year to year to year. Like other disciplines, therefore, it was able to simply roll over one semester's topics and approaches and data to the next.

Ah, the luxury. Course outlines needed revision only for some brand names or camera model names, an occasional change in shutter speeds or, in the pro world, lighting instruments... it was easy.

But it was not to last.

Only a few practitioners were even remotely aware, that from the mid-1980s and early 1990s a new world, a revolution of devastating proportions was percolating just under the radar. It was a new technology that was coming online that would change that simple, happy, stable little world forever and, with that change, force a change in both professional practice and in the education of the entire discipline.

And academia, the bastion of photo education, appeared to have been totally oblivious or, if it was aware of this impending revolution at all, wrapped itself in deep and delusional denial.

But when it came, it fell on them like a machine gun at the battle of Hastings.

Figure 1 Source:http://www.compendian.com/2013/10/dealing-with-the-im-too-busy-excuse

This "Normalcy Effect[1]" was as alive and well in the photo educational community as it ever had been. Photo educators, those charged with preparing their students to meet the challenges of the world they will face when they graduate from school and enter the work force, were among the least likely to accept, much less embrace, the new technology, preferring instead to assert it was just a "fad" and the shooting world would

[1] *The "Normalcy Effect" refers to the bizarre situation where humans so reject change, especially what is to them negative change, they refuse to accept it. What is even stranger is that studies have shown that the closer one is to the danger point, either in time or distance, the greater is their rejection of the reality of the danger. This was sadly observed in my home of Colorado when an old but large reservoir dam, "The Big Thompson Dam" finally failed. Its imminent failure led to repeated evacuation warnings up and down the steep-walled canyon below the dam but the residents closer to the dam itself were the most resistant to the evacuation orders while those further away "down canyon" evacuated from the earliest warnings.*

quickly return to the tried-and-true traditional approaches.

As we'll see, some things never change. But to fully understand the present conundrum we need to fully grasp the history of our discipline and its technological changes.

Meantime, away from the safety and isolation of academia, by the middle of the 1990s the professional world, the world that actually had to practice the art and craft of photography for a living, was already being impacted first by software that created unheard of editing power and options, and then by equipment that changed the conversion of light energy into a tone from a chemical process to an electronic one.

The change overwhelmed many photographers. It was the first technological innovation in the art form's history in which the results of the new technology were judged by the technical or aesthetic criteria of the previous technology. Perhaps this was due in part because at first the new digital cameras were little more than toys.

The Sony Mavica™ shown here created (by today's standards) tiny files (25 highly compressed JPEG files on a single 3.5" 1.4 Megabyte "floppy" disk) ... but it at least sort of *looked* like a camera.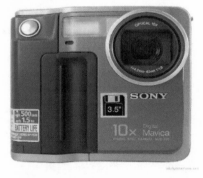

It used then standard video technology to create a single NTSC video "Frame" at a resolution of 72 pixels per inch

(PPI) at an image size of only 720 x 480 pixels. But despite those shortcomings it worked, worked well, and was a harbinger of where things might someday be going.

At the same time, a camera made by the Polaroid-Land Company could produce a nearly instantaneous small, one-of-a-kind print. But this little beast and its digital technology instantly produced 25 image files that could then, immediately, be edited and used as prints or files to transfer.

Companies sprang up that would take your floppy disc and from it produce "index prints" and make actual photographic prints and workable files for you. As has been the case through much of photography's history, technology was being consumer driven. From huge cameras and glass plates to flexible film and small cameras it was the vast consumer market that was addressed first, professionals were quick to follow. Academics... well... not so much.

To compliment this, and spread the joy into the professional ranks, those companies also would take your film hot out of the camera, process it, scan it, and send you back a CD full of multiple resolution files of each image. Now all you had to do was edit them.

Adobe Photoshop™ version 1.0 hit the photo world in the late 1980s and early 1990s. By today's standards it was little more than a tinker

19

toy, only marginally better than Microsoft's basic "Paint" program. But it allowed the editing of photographic files as nothing before had done. And it quickly led photographers into hybrid workflows: first shoot on film, process normally, scan the results, edit in Photoshop, then output the finished file(s) to a device called a "Film recorder" that converted the electronic file back onto film that could then be processed normally for prints or other output such as color separations.

But the technology, at least for the working commercial photographer, was going nowhere professionally until a high-quality capture device, a REAL professional digital camera capable of outputting images that were competitive in the professional world of film was available.

Back then, in those ancient days of 25 years ago, photographers were not commonly also computer geeks. Indeed computers were often seen as the enemy from their perspective, a perspective often fed by the real computer geeks. It was unthinkable, bordering on artistic blasphemy, to think that the computer was destined to do all of the work for them one day.

To the photographers' minds that was telling them that they and their skills and talents would someday be obsolete, an untenable concept.

And this fear and loathing wasn't helped when one of the first workable pro digital "cameras," the Foveon Studio System Camera™ turned out to be in fact a Compaq™ laptop, with a Canon™ lens mounted on a moveable yoke and driven entirely from the computer keyboard.

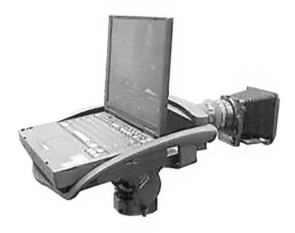

For many, this was a nightmare come true and staring them in the face. Slapping their foreheads in despair, they were seeing a cruel joke on the artistic world happening right before their eyes and, horror of horrors... it actually worked. This had to be the beginning of the end for art, at least photographic art and photo artists.

Others, however, somewhat less given to negative hyperbole, saw the inevitable and started quickly to embrace the new technology and its increase in artistic options. The Foveon demon pretend-camera actually produced a very high-quality image even if it did not have f-stop rings and shutter speed dials "where they *should* be.".

But the very idea of a computer—a camera chimera intellectually and emotionally paralyzed many fine art photographers as well as some photography instructors. This was clear evidence that Chicken Little was right after all... the sky really was falling and it was falling in bits and bytes, ones and zeros... oh the horror...!

Fear is a horrible thing; it blinds one to options. In this case it blinded photographers and photo-educators to the power of the computer world. Most had never heard of a man named Gordon Moore or his assertion in those

21

ancient times of 1965 that, in effect, computer power would double every 2 years.[2]

What we call a "digital camera" is, despite that it now *looks* like a camera, basically, like the Foveon, it is a computer with a lens hung on it. One cannot fully grasp the modern world of professional photography without grasping that core fact and all that it implies.

In the years following the Foveon Studio System, the laptop case has been removed and a dedicated CPU, circuitry, and storage has been stuffed into a gutted camera body[3]. Keyboard keys have been replaced by buttons and dials that look like the old camera controls for aperture, shutter speeds, ISO, etc, but are basically dedicated command and function keys making changes to electronic functions and computer commands.

[2] Moore's (co-founder of Intel Corporation) actual (amended) projection was that the number of transistors that could be placed on an integrated circuit would double every 24 months and with that miniaturization, more could be used and therefore computing power would double. The initial prediction in 1965 was that the time period would be a year. He amended that to two years in 1995. Reality split the difference for him. It turned out that the change happened about every 18 months so anecdotally "Moore's Law" came to be that computing power would double every 18 months. Despite multiple predictions that it would end or reach a saturation point, It is still very much alive and applicable and shows no signs of slowing down as quantum mechanics and nanotechnology infiltrate the computer science world.

[3] Kodak fielded the first serious entry, the DCS100, in 1991 using their own proprietary chip and software stuffed into a gutted Nikon F3 body (Nikon'sthen top of the line film-based 35mm SLRs) The DCS 600 and 700 series from 1999 and 2001,were based on a Nikon F5 It was ultimately deemed a failure because at the time no one was fully aware of the optical issues involved in trying to capture an analog beam of light onto a photo sensor chip filled with sunken "wells" of receptors in a tabular array with spaces between them. Worse, manufacturers like Nikon and Canon denied there was a problem despite it being obvious: soft images files. Olympus secured a place for themselves in the digital revolution by admitting the problem and making a marketing campaign out of their solution. The others, despite their denials, had no option but to follow along.

The entire professional photo world is inundated with computers. The modern digital camera may not look like it but it *is* a computer, the computer on your desk with editing software is obviously a computer, the printer is a computer, and all of those parts are subject to Moore's Law and gaining exponentially in operating power and functionality.

At the same time, the world of computing in the broad sense, a world to which we photographers are now linked, like it or not, is also undergoing its own revolution of power and reach into our lives. And because computers are used now in EVERY aspect of human endeavor, the result is that in ways undreamt of just a few years ago, our little art form, our isolated (or so we thought) discipline for image making, is now being influenced by areas of endeavor and intellectual exploration scarcely imaginable even when our world celebrated Y2K. I don't mean just other art forms, either.

We are now, suddenly, and surprisingly for some of us, part of a huge, seemingly chaotic network and systems of networks way outside our normal "wheelhouse." They may all appear unrelated, but Complexity Theory (which few photographers ever heard of) shows us that the apparent disconnect on which we relied is a myth; it is part of our delusion of isolated safety from change and outside influences.

Here next is a chart I created to illustrate some of the contemporary network systems and their influences on our world of professional photography... and therefore on the future of our discipline and how we must teach it.

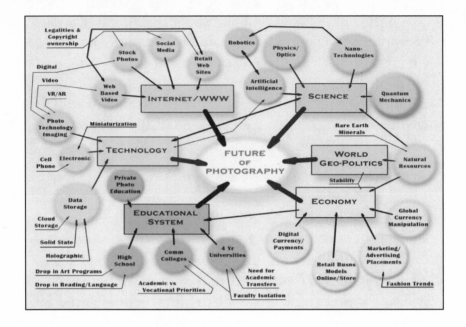

1: Chart of influences on Photography (c) N. David King

We can disavow it all we want; we can cling desperately to our sense of normalcy as tightly as possible. But the world that is influencing our discipline is not going to stop evolving. Worse, the speed of that evolution will continue to accelerate as the sciences and technologies involved feed on and off one another.

The inescapable fact is that every item on that chart carries with it an influence that crosses into the world of professional photography and/or the part of the academic world charged with photo education. I created the chart for this document, but, extensive as it is, I do not, by any means, think or claim that it is truly exhaustive... it just hits the high spots and major sources of influence.

And that means, if we wish to be good, valid, relevant teachers; that is, if we have any hopes of turning out

students who will be capable, in 2 or 5 or 10 years of coping with the real world that will be waiting for them even if it does not yet exist, then we must do everything we can to learn that world beyond our narrow discipline, understand on at least a conversational level those *other* disciplines and issues and learn to predict how they will impact our own network as well as possible.

We must do that if we are to be able to identify trigger points, and constantly adjust our programs and their courses to reflect not the world of today, but the world our students will face when they graduate. This is very different from the unchanging disciplines of, for example, math or real (as opposed to revised) history where core data is consistent across times and places. Our discipline does not operate in that world of intellectual luxury, isolation, and stability.

There is no way around it… that is a little bit disorienting and a lot intimidating. We just wanted to be able to take photographs and teach others to do the same. But we have stumbled into and been enveloped by a completely new world with issues, connections, influences, and futures for which we were never really prepared.

If we want to call ourselves educators, that is the world in which we find ourselves and which we must *master* so we can help our students to do so as well.

And that also means that the administrations overseeing those photo programs like ours, if they truly want the programs to be successful, if they see value in turning out students who can rapidly and successfully enter the workforce and become part of the tax base, they must

also be willing to accept, if not embrace, the fact of this near constant upheaval and be willing to follow and support those changes whenever and wherever it is necessary.

The purpose of this document is to make at least the more powerful of those influences clear, to illustrate that the world of professional photography is changing, to demonstrate why and how those changes are happening, and finally to propose educational modifications in terms of course and program changes to reflect those changes and help prepare our students to be successes in the real world of their chosen work.

Instead of that difficult path, in the past we were able to get away with preparing ourselves for a much simpler world. Some got into Photography instead of the 'Traditional Fine Arts' (painting sculpture, etc.) because they thought it would be easier and never anticipating the technological underpinning involved.

We read and followed the simpler paths of our precursors and assumed that is how our world and our art would always be. And why not? It had worked well and remained substantively unchanged for over 100 years. The bad news is...that reality is dead.

Today's reality is that it is probably not going to work for another 5 years... and certainly not for another 10.

The distressing truth is... it is *not* really working *right now*.

So, to paraphrase a famous movie line, if you are in anyway involved in professional photo education then fasten your seat belt, you are in for a bumpy ride. If

history has taught us one thing it is that the leap to the next plateau is never easy nor free of risk. We humans are often paralyzed with fear when facing the unknown.

We have the cliché ringing in our ears about staying with "the devil one knows" as being the most comfortable course of action by intellectual and emotional comparison. Conquering the fear of that risk, or any risk for that matter, is sometimes motivated by the awareness and the simple observation that the "known" is actually worse or more painful than the "unknown."

In our case the "known" is that even if we cannot predict the future with certainty what we CAN predict with certainty is that it will be very different than today. With a little research we can know with certainty, that the differences of tomorrow, based on the observable influences of today, will more likely than not mean that continuing to follow the approaches based on yesterday (not even *today*) will prove disastrously unsuccessful.

Surely it is time to put down the shovel and quit digging... We'll set off this version of the 30-second stare process by more closely examining some of the influences noted in the chart above to see just how they are effecting the discipline and its future and, therefore, how that discipline must be modified to be properly taught to students. Before we can draw any conclusions, we need to examine the following categories of influences based on the chart above.

- Influences: continual and not on the chart
- Influences on capturing images
- Influences on distributing image
- Influences on the business of photography

- Influences on the SDCC Photo Program.

Then we'll draw data from a survey of photo related sources such as equipment manufacturers, retailers, professional working photographers, and photo educators. And, finally, we'll use all of that to propose some modifications to standard photo educational programs such as ours and address why, in a time when STEM programs are also becoming critical to prepare students for many positions in the newly evolving world, so too is the preparation for students entering the professional visual creation part of that world.

All of these influences point to one main conclusion: in a new paradigm, we are facing the confluence of what on the surface are conflicting trends. One is a growing complexity of scientific, philosophical, technological, sociological knowledge and understanding. The second is the merging of the results and conclusions of those disciplines into almost every aspect of our lives.

In the very short term, education on all fronts, including ours, will have its hands full and the time to start planning for that is right this moment.

Part One: INLUENCES

It needs to be clear that our discussion here is informed by the fact that the program in which I teach at San Diego City College is an "Applied" program. That means that, like all vocational programs, (that term is in disfavor these days) our program is designed to prepare our students for the work place, in our case through the production and provision of photographic images: "Photographic" meaning that the images are created using light and optics to "draw" the final image as opposed to using paint or a pencil. Our mandated goal is to prepare future professional photographers to enter the work force. Our "vision" was to be the best possible at accomplishing that goal.

But the term "professional" in its traditional envelope of photographers in such areas as portraiture, fashion, product and advertising, photo-journalism, etc. may not be sufficiently well defined for our purposes.

A landscape photographer who creates photographs as wall-hanging art still needs to be successful in a business sense, i.e. they need to sell their work to survive and so are as 'professional' as anyone. More to the point, their marketing efforts, if they are to be successful, are vulnerable to the exact same needs, trends, influences, and publication options and

constraints as any other creator or retailer of products and services.

The main beneficiaries of our applied program have traditionally been the students dedicated to real commercial photography, i.e. making images to help clients SELL products and services and to make money with their photography. Those make up the larger part of our student body. We also serve a few students who simply want to be better photographers, a few future photo-based artists, and a few that want to become teachers themselves. The shared commonality of having their chosen world of photography changing out from under them means to serve them all we, as the educators, have to come to terms with it ourselves. And that means we need to come to terms with the areas of influence setting those changes in motion. And it also means that our program, to remain viable, has to reflect that new and changing reality.

INFLUENCES NOT ON THE CHART

The chart shown in the introduction lists influences on the future of photography coming at us due to our evolvingly complex world. Before we get into those, there are, however, some influences on photography that have been with us forever and still are. They are not having a major effect in changing the future of how we perform and make a career of our craft technologically, but they do and always have had an effect on the quality of the product we create and therefore an influence on how we teach going forward. It turns out we cannot ignore those just because they are pre-existing.

In fact, as you will see in the conclusions, some are more important than ever as a foundation even in the evolving world we'll reveal. Here is a list of some of them:

- Aesthetics and Rules of Composition
- Psychology and issues of Perception and Color Response
- Business and Marketing skills for business creation, accounting, etc.
- Legal and Ethical issues

Let's take a quick look at these before we get to the main current and new influences.

AESTHETICS and RULES OF COMPOSITION

We have the ancient Greeks to blame for this. Believing, in their rational minds, that everything, underline EVERYTHING including concepts of beauty, was knowable and therefore could be quantified, they enumerated rules for an image's arrangements and element relationships and shapes that are still with us today for the basic reason that human perceptions are pretty much the same as they were 3,000 years ago... and they work.

All manner of theories abound as to why those old rules still work so well. Why, for example, is an arrangement following Euclid's Golden Ratio or movement aligned with the Golden Spiral so universally appealing and pleasant? I've not read one explanation I think is the final word on it, but the results are too statistically common to deny: following those ancient guidelines results in imagery that is better accepted and

appreciated even today than by purposefully or unknowingly violating the guidelines.

Therefore, even though this is hardly new technology or insight, it is a continuing influence on all forms of visual composition that cannot be ignored. And as we become more and more technologically autonomous and homogenized, I believe, as will be discussed later, it will actually take on increased value.

PSYCHOLOGY, PERCEPTION, COLOR

Psychology, especially in some special areas impacting visual design such as Gestalt-based theories, tell us that with the exception of a very few culturally induced specifics, humans have predictable emotional responses to not just the perspective and arrangement issues noted by the Greeks, but also to certain colors and patterns.

Those issues of perception were mandated study when I was in art school because it was understood whether we, as artists, intended it or not we were in fact going to attain some predictable emotional responses in our audiences. It was important that those responses were of our choosing and intention, and not accidental. Those influences are still at play and will remain so until the human species undergoes some fundamental evolutionary changes. They should already be incorporated and woven into our instruction since none of the new influences do anything to negate them.

BUSINESS and MARKETING

We'll see below how modern business practices have changed in response to technology just as our photo businesses must also do. Marketing techniques have changed with styles and trends. But underlying all of those changes is a constant: to succeed in our "art," we must succeed at the business of providing it for a fee to collectors who want our products and/or to clients who need our creative services. The specifics may change but the underlying need has not and is not likely to in any foreseeable future.

So just like those professionals we read about, we will need to remain current and active in our marketing and business skills regardless of where the future will take us in terms of how and with what we produce our products and services.

LEGAL And ETHICAL

"The Law" is the device by which a society codifies its values and ethics into a system of rules and regulations designed to allow us to interface with one another harmoniously and do business with one another – an inherently antagonistic activity – in predictable, defined, and mostly civil ways.

Commonly accepted law is the glue that holds a culture together, and the honoring of the Rule of Law is the unique concept under which this country was formed and has tried, with occasional aberrations, to be the best we can be. It was the acceptance of that rule of law that allowed, even demanded, in contrast to most other

countries at the time of our founding, that in a court we accept someone's oath as a measure of truth and not the story obtained through the application of unbearable pain and existential fear.

It was the rule of and acceptance of the law that allowed the highwaymen and robber barons, in many cases the fire-brands and sometime dregs of Europe to come together, and build a society that turned that internal fire into productivity and resulted in a culture that channeled the poster children for Robert Audrey's concept of us as inquisitive, acquisitive, and territorial, and turned our unique culture into the magnet for most of the world without having us kill each other off wholesale or slide back into the inherently corrupt *'Padron'* or "Big Man" social systems common in much of the world even today.

And like all other businesses, i.e. entities that produce, buy, and sell among each other, there are areas of the law that all professional photographers bump in to with regularity. Of course, the standard issues of fraud and contract law apply, but notably unique are issues of our rights, specifically enumerated in our Constitution, as the authors of intellectual properties, to the fruits of our own work, and the prohibition against absconding with and claiming ownership of the work of others.

Because we often work in public areas, we also run headlong into issues of privacy and property rights. And of course, our sometimes cavalier attitude towards how we do business, the stuff of cliché, also brings us the unwanted attention of the tax folks who are pretty sure, often with good reason, that we have played loose and fast with the tax code.

Those are influences on how we work that have always been with us and likely always will. While we need to keep abreast of changes in the laws flowing from technological changes that effect us, what does *not* change is that there are laws that DO effect us and none of that is likely to be diminished by the influences this document discusses.

OK, now on to the new stuff... We are here to examine some of the current and modern influences currently effecting the world of professional photography and, by extension, the world of photographic education. I'll break it down into, first, influences on capturing images and then influences on the output and display of those images as well as on the business of being a professional photographer. Those are the areas that we, as a vocational or "Applied" program must address accurately if we are to meet our state mandated charter.

INFLUENCES ON CAPTURING IMAGES

THE SCIENCES

The practical dividing line between science and technology is a blurry one at best and it is no clearer in the areas of influence on our discipline. As they say in social media, OMG! There is so much happening here we can only hit a few high spots to make the point that trying to embrace the *status quo* in our teaching and practice of photography absolutely dooms our students to a status of simple irrelevancy when we send them out the back door into the real world.

Some pundits have coined the mantra that "The future of photography is computational" reflecting the reality that modern digital cameras are basically computers with a lens stuck on them. As Moore's predictions have proven to be not only true but actually somewhat understated, computer science has advanced beyond even his imagining 40-plus years ago. And that scientific leap has seen astonishing changes in camera technology powered by not just more powerful processors, but by the expanded possibilities of incorporating other areas of science into the computational world. Following are some examples.

CURVED SENSORS. A major drawback of the standard camera sensor is that it is flat. Unlike the curved retina of the human eye, the camera's lens, which though focused on a radial concave hemisphere at the scene, is forced to try to flatten those captured rays onto the sensor with minimal distortion and focusing issues. But what if the sensor were curved?

That would solve a lot of optical problems but there was no choice with film's transport mechanisms if the film were to also be held flat and not buckled and not be scratched in the process. But what about now with an unmoving digital sensor? Currently these sensors are built on a silicon wafer or disk and are solid and flat. But do they have to be? And if not, where might that lead?

Work is now underway at several labs to take a curved sensor (already possible) and fit it to a camera. However, that improvement creates a whole new set of problems. It would, for example, entail a complete redesign of the camera lenses to, essentially, undo all of

the efforts to flatten out the projected image at the film plane. But the result would be distortion-free images with greater clarity.

But that would mean the curvature would need to be flexible to match the curved projections of lenses with different focal lengths. Like the human eye, for example... Speaking of which...

Samsung is taking that, and the concepts of human/digital integration from the arenas of robotics and AI (Artificial Intelligence) and curved sensor technology to its logical extreme and is now experimenting with a digital camera integrated into a contact lens. Note this is not a case of replacing an eye with a camera, but enhancing existing human vision.

PIXEL SIZE AND COUNT. But whether using flat or curved sensors, a roadblock to the successful application and improvement of that technology in the photo world has been the dependence on hordes of pixels to capture a detail rich image. Sometimes, still caught up in the analog paradigm of film and grain and how that previous technology rendered the image, we've been slow to understand the computerized world in which we are now operating, much less understand the interaction of scientific worlds of which we are dimly, if at all, aware.

All photographers are by now familiar with the constant clamor for cameras with greater and greater pixel counts. There, the limitations were the light gathering capability of the photo diodes themselves. It required larger photodiodes to capture more light without also capturing unacceptable noise.

But there is a good news/bad news catch: The good news is that the greater the number of photo diodes the finer the detail that could be captured (resolution) – assuming that lens designs were keeping up with the need to focus ever smaller points of light in ever straighter paths at the sensor surface. But the bad news was that meant each diode had to be smaller not larger. Plus, each improvement entailed the need for a fix to accommodate the improvement when then required yet another fix to deal with THAT result.

Ah, but those computer scientists keep improving the processing of those captured images and now we have smaller sensors competing in quality with larger ones. Cameras with less weight and bulk can now compete with older bigger ones. A lighter more maneuverable camera with equal image quality allows for stylistic changes logistically impossible before. And it allows more room in the camera body for other devices such as a GPS receiver or a WiFi transmitter. And that allows a photographer on a remote shoot to be transmitting captured images in real time to a technician and photo editor somewhere else...*anywhere* else.

The photographers shooting the Dearforff, or even the Hasselblad shown in the introduction, could not have even imagined the possibilities opened up by these scientific breakthroughs. However, as they yell at you on late night TV adds, "But wait... There's more!"

NANOTECHNOLOGY. Nanotechnology has contributed to the ability to create smaller and smaller photodiodes and the wiring to each one and the micro lenticular lens array over each one to properly channel incoming light down into the sensor well on the chip. Canon's 50-

38

megapixel sensor now has photodiodes of about 4 microns in diameter. To put that into perspective, a human blood cell is about 5 microns[4] in size. And if the creation and manufacturing of those tiny photodiodes and their wiring isn't enough to let you know we are into some incredible stuff, remember that over every one of those 4-micron photo diodes is an optically correct lenticular lens precisely re-directing light onto the sensor.

Still, as suggested, for a specific sized chip, with each increase in the pixel count, there is a mandatory decrease in pixel size and therefore given basic physics until we develop a quantum sensor there is a limit.

Or is there?

It turns out the answer is, "Yes, but there may be a better approach."

TINY SENSORS. Researchers at Rice University have already created a one-pixel sensor. Believing that all this megapixel obsession is nonsense, Kevin Kelly and Richard Baraniuk believed it was possible, mathematically, to reverse the common compression routines and start with a small sample and from it extrapolate to a larger data set which, in the case of an image, expands it to greater detail.

At first reading it sounds counter to the laws of physics, but upon reflection it really is one of those "Duh...!" insights. Many compression routines are referred to in a

[4] *Most of the scientific community has discarded the term "micron" in favor of the more accurate "micromillimeter" since a micron is one millionth of a meter. But photographers and sensor technology still are using the term "micron" to define pixel/photo diode size, designated by the Greek letter "Mu" (μ).*

display of semantic torture, as "lossy" routines. That means that they throw away portions of the image to save space. When those images are then displayed, the display computer manages a sort of decompression-like activity to re-assemble the remaining parts into a visually intelligible whole. It is amazing that it works as well as it does. But until now no one ever asked the obvious question which is, if the display computer does not know where the images started and only has the crippled version to work with, why do we need the original in the first place?

The Kelly and Baraniuk model accomplishes it with an array of tiny mirrors that direct light from their various positions onto the single pixel. In their model, subsets of mirrors activate together and the process is repeated a quarter of a million times in a few seconds creating a database from which the image is extrapolated. Initially just a mathematical curiosity, the concept has proven invaluable in astrophysics.

The recent pictures from the Cassini probe that plunged into Saturn had a problem...image bandwidth transmission over the vast distances prohibited the use of even highly compressed photos using traditional technology. The actual shots from its two cameras (one for wide angle and one for narrow angle captures) were captured on tiny ¼ inch sensors with only a little over 1 megapixel resolution then extrapolated by JPL into highly detailed images printed over 8 ft in size with enormous detail.

QUANTUM MAGIC. Remember when I said "until" we develop a quantum sensor? Well, actually that has been done too and using a beam splitter and the bizarre

quantum effects of "Quantum Entanglement" and "Two-Photon Interference" it has allowed scientists to, for example, photograph the earth through otherwise obscuring cloud cover. It seems like some sort of black magic.

I'm sure a real physicist could tell you what happens in a few pages of Martian-like equations and symbols. But in essence, a photon is split into two quanta, one sent to the camera and the other sent to the target. Due to the quantum entanglement phenomenon, the photon going to the camera sees what the photon heading to the target sees and allows the camera to record that which it cannot see directly.

GRAPHENE. Is your head spinning yet? It gets better. The Nobel prize winning research of Andre Geim and Konstantin Voroselov from the University of Manchester into graphene materials has inspired additional research that makes it possible to create very large 3D holographic displays on very light, very thin substrate. Graphene is a relatively new man-made and somewhat miraculous material we are just beginning to understand and use. We are beginning to understand how it can be used as a super-conductor in normal temperatures, by itself a major thing. But this work with holograms carries with it the potential of the material's use as a capture material and that, if developed, would be just one more scientific game changer in a long list. How does it work? I have no clue; I'm a lowly photographer not a physicist.

Like much of this new world it is virtual magic to me. But as HAL the computer asked Dave Bowman at the end of the movie, "2010," "What is going to happen

now?" Bowman simply replied, "Something wonderful." As the bull riders in the rodeo say, "Screw your hat down and take a deep seat!"

PLENOPTICS. 'Lightwave' research from MIT and Stanford in the early 2000s has already given us a modern digital version of the "Plenoptic" camera of many lenses capable of creating 3D images from a single capture by, at the same time, capturing the *angle* of each of the light rays being focused on the sensor. It turns out all of the stereoscopic data normally needed for 3D capture is already contained in the light stream but normally not used because it could not be captured or measured. This has led to a simple consumer 3D toy camera (the "Lytro") and also a serious scientific tool now being used used for quality control.

By capturing and manipulating the exact same elements, i.e. the angles of the incoming light rays, it also allows for *retro-focusing* the image AFTER it is captured... now THAT has to be some form of magic. Imagine it combined with video...It is a godsend concept for event shooters. What other image related data that might be contained in those light rays is being explored as we speak.

According to PDN (Photo District News) online magazine "Pulse" (August 2017) things are moving and changing so fast in the world of photography that, "In five years our DSLRs may be seen as collectible relics of the past."

Re-read that last quote. Five years. What does that portend for educational institutions and instructors charged with preparing their students to enter that

world in roughly the same time span? Can you imagine the possibilities of combining just these few scientific breakthroughs? You can be sure someone has and is already thinking about making it work.

So which is science and which technology? For our purposes perhaps, it doesn't really matter since both are being major influences for professional photography and the line, in our world, is somewhat arbitrary. So here is our own completely arbitrary line.

TECHNOLOGY

Technology (like the science that underpins it) has always been a doubled-edged sword. For each positive promise for future benefits there are an equal number of pitfalls on personal and individual levels. In the analog world of film and chemical-based photography, technological advances swirling around but contained in different disciplines made virtually no difference to the practice or logistics or procedures of the industry. A new photo paper now and then, a better film or developer now and then... but essentially little changed from a practical standpoint.

By tying image capture to the computer, digital photography was a major disruptive technology that utterly changed the photo-related world. Now every technological breakthrough that had an effect on computers and computer-related technology had a sometimes subtle, sometimes not-so-subtle effect on photography. And the effects were not only felt in the realm of image capture, it was felt, as, or even more strongly, in the realm of image use vis-à-vis commercial client needs to sell their products or services.,

On the capture side, it has made possible resolution and color depth from a small format camera capable of equaling the output quality of medium and large format analog cameras. That alone was a game changer in how photographers used cameras and that effected styles and fashions of photographic "looks" appearing in advertising.

But a major disruption, within the ongoing first disruption, came in September of 2008 with the introduction of the Canon model 5D MkII. This camera had over 20 megapixels on its sensor, reason enough to want to use it because it was easily capable of matching the output of medium format film cameras. But it added something totally new right out of the box... the ability to capture FHD (Full High Definition) video (1920 x 1080p) with the flip of a switch on the camera body. This was revolutionary for a reasonably priced camera.

To put that in perspective, most TV sets in the early 2000s (and even currently for that matter) are based around the broadcast standard HD (High Definition) resolution of 1280 x 720p[5]. Over 80% of today's TV stations still broadcast in that resolution because it is too expensive to switch equipment, and the bandwidth requirements for the now standard satellite distribution is too limiting. Many small independent stations are still reeling from the costs to upgrade from the old standard 4:3 interlaced resolution to SHD and making another major upgrade is simply out of the question economically... For now...

[5] *The "p" following the resolution stands for "Progressive scan" to distinguish the way the image is created on the screen from the old interlaced approach which is designated by a small case "I" after the vertical resolution.*

A lot of people paid no attention to this development, seeing it as a gimmick or toy. But Vincent LaForet, a filmmaker in New York, realized instantly that it was far more than that: it provided a means to make professional quality video, even cinema quality (based on the standards of the day) with a less than $5,000.00 investment in a comparatively small and light-weight camera that could mount all of Canon's line of high quality lenses and be easily "rigged" with all the necessary bells and whistles for serious video and even digital cinema needs.

True, it could not match the footage quality of megabuck digital cinema cameras from Panavision or Arriflex and it lacked some of the functionality of the RED or Black Magic digital cinema cameras. But almost any aspiring filmmaker could buy one, it did not take equally expensive camera supports to hold it, and it could be used more loosely and spontaneously which was a goal of many independent filmmakers of the time. The success of LaForet's short-short film "Reverie," shot entirely with the 5D Mk II soon after its release, was all it took to open the floodgates for DSLR-based filmmaking.[6] A breakthrough that was not lost on clients.

Why was it a big deal? Once again the prime mover in all this was, and is, money. We need to put these influence categories in "real world" perspective to gain a better understanding of what is happening.

Science, *pure science* that is, is driven by man's quest for a greater understanding of, and, to be honest, control of,

[6] https://www.youtube.com/watch?v=IpspSS07clg

nature. Technology, however, is driven by money. Technology uses the discoveries of science and applies it to our daily lives. The often stated goal of making the daily tasks of life easier has value to people.[7] That is translated into their willingness to pay money they have spent time earning for such devices. Getting that new technology to the consumer is made possible by investors who see the technology appearing on their radar in what is sometimes referred to in some financial investment guides as "**The Technology Innovation Curve.**"

This "S" curve goes through three major phases as it progresses through time. The first phase, the "toe" of the curve, is the "Innovation" phase when scientific insights are being morphed into real, tangible devices – technology -- that can directly or indirectly effect our lives. At this phase these innovations are taking place in labs and workshops and not well known to any but insiders or perceptive investors.

Once a workable model is feasible, then, with investor money, manufacturing and marketing take place and the curve hits the upward trending straight-line portion known as "Acceptance." This is where the real money is made for especially those whose insight got them into the game early. At this stage the word gets out, consumers flock to it, its values are recognized and sales soar. But the curve isn't played out yet...

The "shoulder" of the curve is labelled "Saturation." This is the phase when either nearly everyone has the

[7] *The real "value" of something is best determined by how much of what you call "life" you are willing to give up to acquire that something.*

device, or its benefits have so aided but then levelled the playing field that sales start to fall off and finally go flat.

Multiple influences now force new technology forward. As sales flatten, investors abandon ship looking for something at the next "Innovation" stage. At the same time users of the technology, if it was something to enhance their productivity and competitiveness see their competition all catching up and they too are now on the lookout for the next innovation that will once again give them a competitive edge.

This sequence has played out over and over but there is a symbiosis between science, technology, and economy such that the rate of turnover of technologies increases as science progresses and as the economic impact spreads out over a larger audience. In the photo-imaging world this technology cycle has reached a rate of turnover that is dizzying. The impact of the internet and instantaneous dissemination of awareness of newly arrived technology drives the "Acceptance" phase as nothing before ever has. But that also accelerates the rate at which it hits the saturation point.

When, not all that long ago, a broadcast quality video camera sold for $30,000 and UP *minus* the lens (another $10K-$20K or more for cine lenses) and batteries were $300-500 each and boasted a combined weight of upwards of 40 pounds requiring a $5,000 tripod with a $3,000 fluid head[8], the development of incorporating high quality video into an existing and affordable still camera was a huge deal.

[8] *Actually, you can STILL pay that much for high-end broadcast gear!*

But the Canon 5D MkII didn't just weigh less, it meant that for under $5,000 – 1/10th of the normal investment – – you could now compete, at least on the equipment level, with professional video production houses and TV stations.

Now the technology has again flipped the equation. Where, once upon a time (in the distant pass of about 8 years ago), still cameras gained the ability to capture broadcast quality video, we are now, alongside that development, being driven by entertainment needs to create video cameras (or as they prefer, "digital cinema cameras") that incorporate a stunning and unexpected by-product: the tangential ability to capture professional quality still frames.

It turns out that video cameras capable of 4K, 6K, 8K and better resolution on sensors from "Super 35" to APS-C formats can produce 15-20 megapixel still frames. That actually is a very big deal.

If you are a sports or event photographer, even a wildlife photographer, that capability offers some amazing and tantalizing possibilities. With a camera shooting at 30, 60, 120 frames per second, you'll never again have the defining moment happen between frames. And you can then deliver stills to print media and video to broadcast media from the same camera shot at the same time. Of course prices, sizes, and weight will need to come down to make it really practical, but it is only a matter of time.

And in the interim, the currently available Lumix GH5 still camera, which can also capture 4K video, has a pre-burst mode that uses its internal video capability to be looping constantly so that when you press the shutter

release it captures 30 frames from *before* the release and 30 frames after it.

But that is all just part of the full picture. At the same time, as we'll see below, technology and the internet were fielding a companion change to the industry in how all imagery, including video, could be distributed that was just as disruptive. And remember, it took the analog photo world 150 years of slow improvement until the digital revolution hit. We've seen more development and improvement in the last 15 years than in the 150 preceding years.

Video too has a similar history. Traditional TV had nearly a 50 year slowly changing technology based on tubes. But now, in just over 20 years we have gone from the world of those backbreaking cameras shooting the old 4:3 525 interlaced line imagery to 4K and beyond capture that is as good on a theater screen as was motion picture film... and that can be attained with cameras costing a fraction of the price.

And just to round out the sampling of technology impacting us, there is a device, currently a separate attachment but destined to soon be incorporated in the camera itself, that reads the 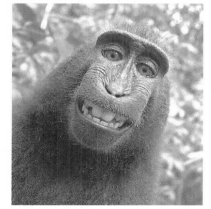 incoming image data, compares it to an extensive internal database of iconic photographs, picks a similar one and sets the camera with the same settings that were used for the stored iconic shot.

We can try to ignore it but cannot escape the game-changing reality that photo technology has brought us to a point where a camera, by itself and without human intervention, is capable of creating a technically competent shot. The proof of that is the infamous "Monkey Selfie." Here a Crested Macaque in a preserve in Malaysia purloined a photographer's camera and took photos of himself and friends. I'm willing to bet the farm that monkey never received a moment's worth of photo education nor, being male, had even read the manual.

ECONOMY/MARKETING

Remember a few election cycles back, the catch phrase for one of the candidates was, "It's the economy, stupid!" It turns out that same perspective applies to far more than simply political attention. It applies to every job that works and plies its trade in the world of business. Without profit, i.e. the money from the revenue from the sales of products or services that is greater than the expenses, there is no money to keep the business going, much less to thrive and grow. Businesses cannot long stay in business if they continually lose money, nor can they stay in business if they simply breakeven; the owner needs some profit money to live.

When the economy is relatively stagnant as it is now, the consumer has less money as everyone's costs keep rising regardless of the economic label. Even if the intrinsic value of an item remains relatively constant, if the value of the unit of exchange (e.g. the dollar) keeps going down, the item *de facto* becomes more 'expensive'.[9]

[9] *A good illustration of this is to consider that the value of an ounce of gold in 1917 ($32,50) would purchase almost exactly the same thing today ($1,270) in a wide*

For businesses, this creates a need to market farther and farther afield and for less and less out of pocket costs. Therefore, vendors who can supply marketing content on that broader basis for less money are the ones who get hired.

Statistics are in and well settled in the advertising world. Over the past year and especially over the past holiday season, advertisers saw a marked increase in sales online, and from those sales a very large percentage came from video-powered ad pitches. In fact 87% of online sellers are using video. Why? Because statistics have shown that video drives a 157% increase in traffic to a site.[10]

That is wonderful news for the manufacturer and retailer. Because of the internet and less expensive video gear it is far less expensive to display their wares and services online than to have expensive insert ads, catalogs, and brochures created. And it is a lot less expensive than 30 second and 60 second commercial placement on television, a venue commercial-free streaming is killing anyway.

Better still, those ads can be BOTH targeted far more widely and at the same time directly to an identified demographic... and updated immediately and easily. The result has been overwhelming: commercial product and advertising photographers are being asked and expected to be able to also provide video material.

variety of products: a high end man's suit, a mid-range camera, or a custom .45 Colt..

[10] *http://www.wordstream.com/blog/ws/2017/03/08/video-marketing-statistics*

No longer an occasional off-the-wall request, this is now common. "thewewsmarket.com," an industry online journal, indicates that the use of industrial videos for corporate use is increasing as both lowered costs of production and increased ease of distribution impact the process.

WORLD GEO-POLITICS

Despite our national identities and squabbles, from a technological and economic perspective we are increasingly a global world. Despite potential trade wars and concerns over trade imbalances, it is virtually impossible for one country to be utterly self-sufficient and to provide all of their own needs from internal resources. That reality has opened up worldwide direct markets that were unthinkable if not impossible just a few years ago.

For example, I just ordered a new video field monitor directly from the manufacturer in China who marketed over the internet. Before that I would have had to find a distributor domestically who would have marked it up considerably to maintain their own profit margin. I recently purchased a set of high speed memory cards made in the UK without going through intermediaries, again because the internet reaches everywhere and though, at the moment, the geopolitical scene is troubling, it is still open for business country-to-country.

That means I can now compete with bigger existing vendors whose equipment costs were much higher (and even after a few years of use may still not be completely amortized) with lower costs and more efficient purchasing. The value of this international trade has

thus far not only served as a stabilizing influence which might otherwise have erupted into conflict some time ago, it has made competition in my field possible that was unthinkable not all that long ago.

And that has created the demand, by the clients that professional photographers serve, for more and more high-tech services to be delivered but without the old world high-tech elitist price tags. And that has initiated a new discussion on pricing. Old rates were much higher but were also based on much higher costs. How to take those out of the equation and retain the value for the shooter's work is yet undefined and still in flux.

But that state of geopolitical stability or instability has another major effect on our photography world in a less obvious way. Many of the components in our imaging technology use rare-earth elements that are not commonly found domestically. Many come from Asia, a few from other potential hot spots around the world.

If our trade with those countries is disrupted or broken, we will have to create, from scratch and on the spot, new technologies using different materials, or return to the analog technologies we have left behind. Or we'll have to develop new technologies not even on anyone's radar.

Things cannot get much more influential than that.

Creativity and innovation are driven by crisis and need when an existing paradigm fails, and no ready solution is available. Sometimes the solution results from a purposeful effort and sometimes is serendipitous. For example, in New York City around 1905 newspapers were filled with doomsayers noting that the city was about to be hip deep in horse manure because the public

department tasked with removal was being overwhelmed.

One solution still used in places where horse drawn carriages drive around city streets was a sort of "diaper" to catch the "road apples" produced by the horses. Of course, the real, lasting solution came totally out of "left field" in the form of the internal combustion engine and automobiles that replaced the horses though with their own forms of pollution driving new technologies to try to deal with that.

We therefore either prepare our students to anticipate and deal with those ever-changing realities in our own "world" by helping to endow them with creative and innovative mind sets, or we cheat them of their futures in our industry. Teaching them to THINK is now even more important than ever.

But the new processes and influences on our world of professional photography do not end with the capturing of an image. Economic value and revenue comes only from being able to make some tangible expression of that captured potential. Yet another new set of complex influences now comes into play at this next stage. So you've made your new images... Great; now what?

INFLUENCES ON DISTRIBUTING IMAGES

Just as this new complex world has improved and expanded the photographer's ability to create images and products to satisfy sophisticated clients, the world has continued to move forward. What we do is, in the

end, driven by what the client perceives they can do with our products and services to serve THEIR needs.

Technology, streaming in from a wide variety of influences, is ever broadening their potentials as well. And that in turn is influencing what they are demanding from us.

INTERNET

The advent of the internet and World Wide Web has more profoundly influenced the world of final image distribution for commercial photography than any other technology. It is not, after all, the *Neighborhood* Wide Web. Anything posted on the internet is essentially available to anyone around the world with a computer or even a cell phone and an internet connection. Back in the dark ages of my day, we were limited to expensive targeted mail lists and then had to create the filler, and pre-sort the mail bundles, and pay the postage. Now it is all quick and free.

Advertisers have seen distribution of their messages and pleas for consumer attention go from handbills to newspapers and magazines to radio to television and now to the internet. But they have also seen, at least in terms of technological awareness and use, their customers and product/service consumers go from well-read and literate, able to handle lots of data, to semi-literate with attention spans measured in seconds.

And with that they have witnessed and had to answer to an increasing desire for greater and faster engagement and entertainment in the delivery of those messages.

Over and over I heard advertisers and art directors speak somewhat derisively of the "A.D.D. GENERATION" and the need to attract their limited attention spans fast with exciting and catchy messaging. The internet's growing abilities have provided marketers a solution with the capacity to present motion-filled and even interactive material as easily, sometimes more easily, than preparing a major insert print ad that just sat there on the page and did nothing.

Some longed for those "good old days" but knew they were gone and to be successful in today's increasingly competitive environment, the new technologies and their presentation options had to be learned, embraced, and exploited for their clients.

And THAT has a direct impact on one of their traditional major content providers: the professional commercial photographer. Those photographers, old or newly entering the field, will adapt their skills to this new world or be trampled in the dust. On the old trail drives a common saying was you "...either make dust or you eat dust." Making dust was a lot better. Riding "Drag" following the herd to look out for stragglers and strays was the worst of jobs.

INTERNET OF THINGS

And like a giant herd of cattle on the move, the major dust maker for us is due to a technological concept that some see as the future of a broad collection of developments clumped loosely under the label of "The Internet of Things."

In a broader sense and in ways many of the consumers are not even yet aware, the 'Internet of Things' is already impacting our lives in incredible if sometimes insidious ways.

Here is a quote from a recent investment webinar by investment guru Paul Mampilly,

> *"The Internet of Things has already made its way into our homes, pockets and onto our wrists...*
>
> *"You can already buy Internet-enabled thermostats, light bulbs, refrigerators, baby monitors, windows and toasters that observe your behavior and adjust to your likings.*
>
> *"You can even buy a toilet that opens, closes, deodorizes, rinses, plays music and tracks usage via a mobile app.*
>
> *"Smartphones, like this one, are used by 68% of U.S. adults. It is central to the Internet of Things. If I enable it to, it will track my every movement.*
>
> *"It will know where I am and communicate location back to apps like Google Maps and Waze to determine where there are traffic jams. It will also tell me where my friends are, play music through my car speakers, check me out with the cashier at the grocery store and so much more.*
>
> *"Of course, there's a lot more to the Internet of Things than just setting the ideal temperature, safely carting us around town and flushing toilets...*
>
> *"It's going to revolutionize every industry on the planet.*
>
> *"To grasp how big this will be, just think about how the "old" Internet changed entire industries...*

- *Amazon put Borders out of business ... but made it simple for us to buy books and thousands of products ... Investors who got in early could have made 1,482% in just 7 years.*

- *Netflix put Blockbuster out of business and could do the same to the cable industry ... but it made it easy for us to instantly watch thousands of movies and TV shows ... Early investors have been rewarded with 1,485% gains in just 3 years.*

- *EBay (and Craigslist) forever changed how we buy and sell household items ... its stock has made investors 547% in just 6 years."*

With the ability now commonplace to distribute our images to each other in an instant, to not just, as in the old days, have the drugstore or camera store develop our film and make prints we could mail to family and friends, we can now foist our travels, even our lunches on the entire world instantaneously and at no cost whether they care or not...

For our professional photographers, however, that means a client can send customers a picture of their product or service as soon as it is made (and update it as necessary) instantly and cheaply. They can target their viewers easily and can send those images to their customers' computers, their watches, their cars, anywhere a monitor can access the internet.

But having reached a saturation point (remember the "Technology Innovation Curve?" with the deluge of still photos, the members of the newly evolved species of

"Homo Teadium[11]" started to get easily distracted from the photos on which we wanted them to concentrate. And now the skill most in demand, thanks largely to the internet, is video capture and professional level creation of marketing/sales and advertising video.

ECONOMY

We've already touched on it, but the state of the economy, or at least the *perception* of that state, is *the* driving force that motivates the manufacturers and retailers and service providers. That force not only helps drive innovation, it is the one thing that keeps the professional photographer in business.

The professional photographer is in business to do one thing – create content that helps his or her client to sell their products or services.

As we noted, the clients of our world succeed and advance by increasing the difference between their costs and their revenue. It is really that brutally simple. Their goal is to get their product or services in front of a greater number of potential customers and at the same time, decrease the unit cost of each "eyeball" while increasing the interest, retention, and behavioral change rate of those "eyeballs."

And that means that we "creative services" content providers are in the business of aiding the process of behavior modification. Our work is to get audience attention over the competition and, once attracted to our content, to persuade them to more readily buy our

[11] *Really? I need to translate this for you? OK, it Is Latin for "Bored Man/Human"*

client's offering rather than their competitor's offering. Those of us who can do that consistently will succeed, those who can't, or won't, will fail.

We may, in a state of unbridled hubris, refer to ourselves as artists (thinking of and aligning ourselves with the traditional fine artists from Michelangelo to Ansel Adams) but in a very practical sense, we are as in thrall to economic issues as any of our clients. (Spoiler alert: so were Michelangelo and Adams.) The bottom line is that in fact we do not sell *images* -- we sell *value*, a value created by selling *dreams*.

If, for example, we take on a job to photograph a motel on the coast to go into a travel brochure or video for a midwestern audience, it is easy to think we are there to provide nice shots of the motel. But at most that is simply a starting point.

Motels are motels are motels (all apologies to Gertrude Stein). Colors, rugs, veneers, vary but basically it is simply a rental room with a bed we hope is clean and in which the multi-legged creatures sharing the space are kept low in number. To that Midwesterner considering a vacation to the coast, our sales piece must sell not just another motel but the *dream* that embodies the vacation for the viewer.

That dream is the real value, not an architectural shot of a common item. They, the client's customers, are not coming here for the motel. Of course they want to stay in a nice place and we need to show that as well. But the motel whose ad best sells the dream will be the one they most often will choose to book. The failure to

understand that and build on it in their commercial work is at the root of most of our colleagues' failures.

AUDIENCE ENGAGEMENT AND INTERACTION

The addition of video production to our tool bag has become such a common request, one of my survey subjects told me any photo school billing themselves as vocational must include that area in their curriculum. But it's not the only way new technology and old technology applied in new ways is coming on board to engage and keep the audiences of potential customers for our clients viewing their advertisements.

AR (AUGMENTED REALITY)

Augmented reality is the introduction of unreal items (graphics, type, animation, etc.) into an otherwise "real" photograph so that it looks as if it were actually a part of the photograph itself. A major example was the recent Pokémon game putting little monsters in the view of your phone camera.

Of course motion pictures were doing this from the days of the Lumiere brothers' trip to the moon. An excellent example of this in film would be, at one extreme, the compositing of live Acton and cartoon animation in Disney's "Mary Poppins," and on the other, the very realistic characters and animals in "Jurassic Park."

61

But still photographers generally thought of this as tacky. Masters of multi-image printing such a Jerry Uelsman, stunned viewers with surreal photo images that looked real but couldn't be... But in general use, it was too hard to do. Nefarious objectives often resulted in some interesting composites pretending to show events that didn't really happen and participants that weren't really there, but the low-level technology made them fairly easy to spot. Until now...

Photoshop with its powerful compositing functions changed all of that. The photo image is still, in most regards, accepted by the public as "real" or a depiction of reality. Of course, it never really has been; but as we all know, perception is reality. And therein lies the power of 'augmented reality' work: creating an image that looks real and may be accepted as real... but isn't.

VR (VIRTUAL REALITY)

Virtual reality is a term used for several technical approaches. Specifically, it creates a whole new world, a "virtual world" complete with elements that do not really exist outside of the viewing experience. Think of a photo-realistic cartoon or rotoscoped[12] film. But in the new technical world it has come to include 360° views and 3D views. When viewed through a VR headset, turning the head produces a change of view just as physically looking around would in the real world.

[12] *Rotoscope is a process of taking live action film and then, frame by frame, introducing new graphic elements or modifying the scenes by eliminating or changing elements captured in the original footage, e.g. "300."*

VR, especially 360° photography is finding a real home in the documentary world though it is not yet making great inroads into the advertising world. But those worlds are beginning to feed off one another so in time, maybe 5-10 years, the outlook will be very different. The only remaining obstacle is ease of viewing. When that is solved it will change everything.

IMMERSIVE PHOTOGRAPHY

This was originally a technology based on computer display capability that allowed the viewer to mouse-click on defined "hot spots" in the image that were links to other images. It also could combine 360° views and even 3D. It could take huge "mosaic" images and allow you to use computer controls to zoom in for minute detail.

The best example of the technique I saw was a beautiful website for a museum. Using keyboard commands, you could look around the room. Clicking on an item brought up details about the item. Clicking on a door took you into the room beyond. This technique quickly found its way into real estate photography for high end properties where buyers could save time with a virtual tour of prospective properties.

Initially one could only view this effect on a computer or link to the Internet. Now the 3D VR headsets make the experience even more real as it combines all of these labeled technologies into a single experience for the viewer. But with more and more internet interaction, that former weakness is becoming less and less of a problem.

The possibilities are endless: virtual and immersive instruction manuals making the viewer a part of the piece being worked on or explaining a system literally from the inside out are only a starting point. Combined with video this has become even more powerful and engaging for viewers, potential customers and clients, and is ever more important for the clients of professional image makers.

Now there is a choice. You can, on one hand, hire someone to simply take a static picture of your product or service, drop it into a brochure, and hand them out hoping someone will pick them up and read them and not toss them immediately into the nearest trash receptacle. You can buy mailing lists to send to individuals you hope will be interested and hope too that it is not instantly dumped as junk mail. Or...

You can lure them to your site or product using targeted social media and then demonstrate clearly why it should be their choice rather than your competitors in an engaging and entertaining way.

It is not a difficult business decision.

INFLUENCES ON THE BUSINESS OF PROFESSIONAL PHOTOGRAPHY

Economic issues being our prime movers, we think we sell images but, as noted before, what we really sell is value, i.e. will the results of our work be worth more than our cost? There are, however, other influences that have an effect on our commercial work and our future

professional success/failure. What are those and what does that mean for us as educators trying to prepare our students for that world?

USE OF IMAGES IN THE INFORMATION AGE

Well the problem, as many in education are seeing play out in the classroom, is that although we are creating and devouring more and more information, we are demanding that it be provided at faster and faster and ever easier means of absorption than before. All of a sudden, the old adage about a photo being worth a thousand words takes on a whole new meaning.

Facilitated by the internet and the World Wide Web, images that were once simply the headlines of an article are now, for many, the entire article because they think that the images contain all of the information they would otherwise have to drudge through if they had to actually read the article.

"Just looking at the pictures" is no longer a joke. Those articles that are led with an image that is a link to a video are, statistically, being viewed at a much higher rate than the accessing of the actual article.[13]

That hunger for images, often substituting for the more comprehensive if complex written articles, has a direct impact on the work of photographers of all genre.

To add some "sport" to it, all of this revolution of technology has coincided with a revolutionary speed of

[13] *How would they know? Well notice how many articles on line offer a few lead paragraphs and then a link to "Read More." Just as the clicks on the link to play the video is captured so is the click on the link to read more is captured for analysis.*

change of styles and fashions. Not just the hunger for pictures and the expanding list of places to put them, but the need to maintain style and fashion relevance to attract viewer "eyeballs" to constantly upgraded products has always driven what is needed and salable from photographers.

Dealing with that constant change was expensive in the print world, although it supplied lots of lucrative work for photographers. But in the online world it is fast and relatively easy. Anyone with a digital camera (including a cell phone) can take a quick shot of the new part and drop it onto the company website.

Photographers are having to do what their clients were doing that paid so well... update and upgrade their value to their customers, i.e. the clients. And we have to demonstrate our value when sometimes, the client themselves, thanks to better and better camera technology and the inclusion of some of that technology into our smart phones, are our own greatest competitors.

The work and need is still there. Our first job is to show that we – the professional – can, despite our cost, give them greater value then they can provide for themselves and doing it for free.

And the biggest growth is in the use, by retailers and others selling products and services online, of moving images. Right now anything that moves seems acceptable, from a simple "pictograph[14]" to full motion video. But as with stills, as more and more try their hand at it, sooner or later it will be obvious that some

[14] *A pictograph is a still image with a moving component, for example a landscape shot but where the clouds or a foreground river are moving.*

images attract viewership (and therefore dollars) better than others.

This has historically been when, after a lull brought on by people leaping into a new technology produce mostly mediocre results, the "eyeballs" in question began to discriminate based on quality and once again started to follow the time-honored marketing dictum of "implied value" where the potential customer assumed a quality level of the product, based on the quality of the packaging. For example, a product presented in a fitted velvet-lined case will be deemed to have higher quality than one presented in a simple blister pack.

There was a time when Flash-formatted, amazingly entertaining web sites were the exclusive realm of major corporations. But there was a problem, the computer power and the limited bandwidth of the early day's internet made them slow to load so products aimed at serious business people with little time to spare, who wanted their data fast and easy to find, returned to fairly simple HTML-based pages where the separating quality was the layout and visual design.

It wasn't long before that playing field leveled out and new ways to stand out were sought to catch attention and provide "packaging" of the web-based "pitch" that carried a high level of implied value. The question for the photographer was, and is, what to do to answer that need. And the question for photo educators is how do we prepare them to be able to search for those answers and then provide the solutions?

LEGAL ISSUES & COPYRIGHT

An artist's rights to his or her own intellectual property used to be fairly clear but has been rendered virtually opaque in the age of the internet and social media. While there were some arcane rules about length of time a right persisted or how it could be lost or transferred, the basics were the same: if it is your unique, original, and tangible expression of an idea, it belongs to the creator unless that right is pre-empted by contractual agreements such as in some employment contracts where a worker's efforts contractually belong to the employer.

But with the advent and spread of social media, and the nearly impossible-to-resist urge to post the latest images on it in every venue from Facebook to Instagram to Pinterest, etc., photographers do not seem to understand that in doing so they have made their work available to virtually anyone who wants to steal it from all over the world.

In fact, the fine print of the agreements to use the sites make it clear the site itself now has some rights to your posts and images. Some, such as Facebook, automatically strip the metadata, including copyright data, from all incoming images. Unless watermarked, an unscrupulous stealer of an image can make a fair case that they had no idea who authored it and had no way to determine it.

This situation is exacerbated by new federal regulations on copyright protection having been steadily eroded over the past few years. The rules dealing with "orphan" work (a piece of intellectual property for which the author/owner is not readily ascertainable) that used to

require the individual wanting to use that image to undertake all due diligence in finding the owner have been turned on their head and now it is the author that must do all possible due diligence to make themselves easy to find. That is becoming more difficult when, as noted, social media sites often strip off the metadata when you make a post on their sites.

With cell phone cameras nearly ubiquitous along with the passion for selfies and the current craze to photograph one's every activity, people are finding themselves in *other* people's photos, now appearing openly online, in ways never dreamed of before.

 Why is that a problem? Imagine in the background of your lunch shot is a clearly loving couple that is not really a proper couple but the actual partner of one of them sees your post. If there is a lot of money and acrimony involved in the divorce proceedings, count on being a witness in one suit and the defendant of another.

The legal system is reeling from all the new capabilities to infringe on well-established privacy rights and their occasional conflict with photographers, especially those doing so-called "street photography." This influence will have a great effect on the practice of commercial and professional photography, but it is currently in a state of flux as the legal system tries to find some solid, stable ground from which to make fair regulations... or perhaps regulations which favor those with the most money at stake which is probably NOT the artists and photographers.

We need to make sure that our students are kept abreast of at least the "droit du jour[15]" and the means for them to monitor the law's progress. That is important for them not only when they enter the real world, but even as students going out to complete projects and assignments. Being a student does not provide a defense against breaking the law. Remember, a core dictum in law is that "Ignorance of the law is no excuse."

PHOTO BUSINESS STRUCTURE

Perhaps the most devastating impact on the professional photographer is the loss of in-house employment. In those good old days of 20 years ago a newly minted graduate of a photo program could still seriously contemplate getting a job in the photo department at a large firm of virtually ANY type that advertised or marketed their goods or services and/or did internal training. But that work environment was already under assault by economic reality, driven by a series of recessions and economic impacts including the oil and gas crisis that hit in the mid-1980s.

Based on the writings of business gurus such as W. Edwards Demming, most notably in his book and theories on "Total Quality Management" business practices, companies looking for ways to get leaner and smarter and therefor retain more of their earnings -- began to examine the principles of what was their true "Core Business."

Companies across the business spectrum adopted the approach that even if consultants and independent

[15] *Fr: Law of the day, i.e. the current law*

contractors doing tasks that has once been done by employees were more expensive on an hourly basis, there was actually a significant net drop in costs. Not only were there no additional "benefits" to bleed the company coffers, they need only be retained when those specific tasks were needed. Loyalty and a nearly familial understanding of the business suffered but the advent of nearly all-powerful HR departments were already killing those aspects anyway so there was not much additional loss.

That saw internal photo labs, and other non-core departments purged from the system at a heart stopping rate. The end results, as new students find them today when they graduate from a program such as ours, is that for all practical purposes, if they want to be a professional photographer they WILL have be a free-lance independent contractor. Period. Even newspapers and iconic editorial outlets like National Geographic and Sports Illustrated now mostly use freelance shooters for their pictorial content.

Traditionally a publication or newspaper would assign a project to a photographer with the certainty that unless the photos were no good, they would be paid the rates of that publication. But now they tell stock agencies what they are looking for. If the stock supplier has it, then they use that. But if not, it might solicit "stringer"[16]

[16] *In journalism, a **stringer** is a freelance journalist or photographer who contributes reports or photos to a news organization on an ongoing basis but is paid individually for each piece of published or broadcast work. .As freelancers, stringers do not receive a regular salary and the amount and type of work is typically voluntary. However, stringers often have an ongoing relationship with one or more news organizations, to*

photographers. "Assignment Stock" is a relatively new category of work that forces the photographer to take on the expense and risk of a "suggested" photo shoot in the hopes that it will then be purchased. It can be an expensive and uncertain game.

That clearly impacts what they must know about running a business; something unneeded by an employee and as foreign as a Martian breakfast cereal to most in academia. It also means that, especially to get started, the newly minted photographers need to know a much broader section of their discipline than would have been needed to get hired to do a specific type of imagery for a specific company.

Later we'll discuss how, in a head spinning change of approach, while seasoned experts may well be highly specialized in the work they do. But as the student is just entering the pro world and is working to gain a reputation and standing, and just trying to find their way in this competitive and cut-throat arena, they will most likely have to seek and accept work of almost ANY kind and yet be able to do it with sufficient competency and professionalism to gain a good references and repeat customers.

While building their business they may find themselves shooting a house for sale and a wedding and a family portrait one week and a sports event and rock band and someone's new product the next. Today's graduate faces a far more complex set of skill needs than ever existed

which they provide content on particular topics or locations when the opportunities arise (Wikipedia)

before when you often started out being specialized rather than evolving into a specialty as you progress.

That has a major impact on photo education because despite the need for specialization that will likely happen once they are established and known in the field, photo education students are ill advised to be narrow specialists when starting out. Our job is not just to prepare them for the arena that *want* to play in, but also the arenas they will *have* to play in to get started.

INFLUENCES ON THE SDCC PHOTO PROGRAM

All of the influences noted above will directly or indirectly have an effect on the capturing or distribution of images in the coming months or years. Obviously, those directly or indirectly also then influence course and program materials and approaches. But there is an even greater impact on the program's success at preparing our students to enter the real world of the professional photographer and that is the educational environment created by and overseen by the college, the District and the State.

While I think this all has an effect on programs like ours all over the country, my immediate and specific concern is for the Photography Program at San Diego City College so here I'll address those directly and from within that context.

EDUCATION SYSTEM Vs REALITY

The State of California has, at least in terms of how it has impacted our discipline and program, its own somewhat unique philosophy of education. I cannot speak to its success in disciplines other than my own. I will let the State's ranking in country-wide educational standards and the numbers speak to that, which it can do far more eloquently, accurately, and objectively (if sadly) than I can. But I *can* address from firsthand experience how well it works in a program attempting to prepare students for one of the world's most competitive, cut-throat, professions – commercial photography.

Simply put... it doesn't.

California's apparent embrace of a system of coddled education may well prepare students for *something*, but it is emphatically *not* our world of professional photography. From the disaster of "motivational grading," (theory: giving students better grades will inspire them to do better) to the embarrassingly inane concept of "reverse learning," (theory: learning is no longer the responsibility of the student but of the instructor) to the bizarre attempt to remodel the failed MBO (Management By Objective) schemes of the business world in the 1980s into the SLO (Student Learning Objectives) efforts that have succeeded mostly in turning faculty into data entry clerks, one failed plan after another has served only to degrade our educational system generally and our vocational programs specifically.

Top commercial photographers can make a lot of money plying their tradecraft, skills and art, but only if they work their way to the top rungs of their regional ladders. That is the part of the world in which they will want to work and for which we ought to be preparing them.

Educational administrators that have never, from Kindergarten on, strayed outside the safety and isolation of the halls of academia, are simply clueless about a world of real competition for clients, of statutes and regulations and business-related taxes and financial issues. They are blissfully unburdened with firsthand experience and knowledge about dealing with employees and all that goes with it, or about having to survive based on one's own unique vision and insight and their artistic and marketing skills.

They have not had to venture into the dark realms where failure has immediate and negative consequences; where the worker is only as good as their last job; they are steeped in theoretical knowledge but bereft of real world experience and therefore not well prepared to show students how to succeed.

But that hasn't diminished or even moderated the hubris involved in telling those *with* that experience how to best educate others seeking to join the world demanding that experience. They act as if they believed that (with further apologies to Gertrude Stein) education is education is education, i.e. that once found for one topic a good educational methodology works perfectly for all topics and disciplines. Admittedly it makes administration a lot easier, but I'm here to state categorically and emphatically there is no such methodology, or to use the jargon of the day, no such

universal *pedagogy,* at least on the vocational side of the educational equation.

First of all, for the professional photographer, as already noted (but so critical to educational needs it needs repeating), the world of in-house employment is all but dead;[17] what remains is the brutal truth that in order to succeed, the graduated student *will* be a "free-lancer," i.e. an independent contractor whose life and success will be totally in their own hands.

This is a world where for long periods of time, 12-hour back-to-back days are the norm and mandated, followed by long stretches of panic and depression where there is no work but must – *must* – be filled with self-initiated practice and growth of skills and talent in preparation for the next cycle... or there will *be* no next cycle.

In this professional free-lance photo world there are no sanctuaries, no safe rooms, no trigger warnings, no safety nets, no participation trophies, no unions to protect dead weight, no mothers to kiss boo-boos, no protections from offenses to over-wrought sensitivities, no steady dependable paychecks, no insurance, NO EXCUSES. If the pro shooter wants constant undeserved adulation, they need to get a dog.

The clients of professional photographers do not care about them; they do not care a whit about degrees or diplomas or certificates. Clients are indifferent to the photographers' ancestry, hairstyle, or potty training;

17 *There are still a very few older companies that maintain in-house photo or video departments, but they are rare and those employees seriously hang on to their jobs. When the employees finally retire the department is usually shut down and its work then outsourced. For all practical purposes, students need to see that world as fading into history.*

they do not care if their vendors are white, brown, black, red, yellow, or green with purple polka dots.

They do not care if the photographer prays to Yahweh, Jehovah, Allah, Ra, Shiva, Ahura Mazda, Gaia, a grey alien, Ming the Merciless or no one at all; they do not give a fat Norwegian rodent's rear-end if the camera person goes home to a male, a female, a mule, sheep, dog, aardvark, something inflatable or battery driven.

When their insertion ad's deadlines loom they do not care if you are sick, your kids are sick, or your pet weasel is sick; they don't care if your car has a flat, your biorhythms are in triple critical, your crystals are out of tune, or if your aura has turned a sickly brown. Students *must* believe this: because if *they – the students* -- do care about such things and think it may excuse failure, they are in the wrong field. And we are in the wrong field as educators if we allow, much less if we protect, encourage, facilitate, and perpetuate those feelings.

Clients care about one single thing and one thing only when hiring a photographer (or, for that matter, ANY independent contractor where company needs are being outsourced): what is the ROI?

Put another way, what is the value return on their investment in that person's contribution to the company's mission and treasury?

Put yet another way, will the work the client receives from this person end up bringing in more money than it cost? We may think we are being hired for our ability to create beautiful images of their products or services, but

in truth most company managers wouldn't know a good one from a bad one.

We are, instead, being hired on our perceived value to the company, i.e. will the photos of their product or service be so persuasive that the resulting sales will bring in more revenue than they paid to do the marketing? If the client cannot be comfortable answering "Yes" to that question they would be a fool to hire that photographer.

And the only relevant tool available to help in that decision is the photographer's "book" or portfolio or "reel" if they do video. Degrees are meaningless to ROI, after all, someone who still got the degree finished last in their class. Perhaps in some businesses those credentials and sensitive issues are important, but they are meaningless in ours.

It is true that back in the nearly dead world of in-house photo labs, once HR departments took over hiring from experienced and knowledgeable managers, diplomas became important because HR personnel were otherwise clueless as to what was important or how to evaluate it. But today, the day of the out-sourced "free-lancer" has made such things all but irrelevant.

The question is not what letters might appear on your letterhead after your name, it is what simply is your "value position" to the company's bottom line as demonstrated by examples of your work.

Consequently, photographers in the field live and die by their ever-evolving portfolios and reels. They understand one basic rule above all else: "You are only

THE FUTURE OF PHOTOGRAPHY & PHOTO EDUCATION

as good as your last work." It is a mantra they will embrace and master... or they will fail. Period.

At some point in their careers, if they are extraordinarily good and their volume of work is prodigious, they might be excused a project that drops slightly below par – the operative word here is *slightly*. But when they are starting out they will have no such luxury, no such safety net.

That is the world to which our students are headed. If it is not the world the students of others in the educational system are headed, then they have no legitimate standing to tell us how we should prepare our students for their futures.

Some newcomers in the process of failing are forever whining that it is not fair.

Of course it's not fair! Get over it.

Neither is life outside some arbitrarily and synthetically "fair" places setting them up for a failure prone attitude and an easily pierced thin skin.

A famous sequence in the iconic and beloved comic strip "Peanuts" by Charles Schulz had the gang deciding they always lost their games because they were not sufficiently sincere in their attitudes about the game and their desires to be winners.

Over several following strips they engaged in exercises to develop a display of sincerity and self-confidence. And it was working. They were feeling ever so much better about themselves and their new-found team *esprit de corps*.

It was with incredible confidence, dripping with sincerity and brotherly love, that they entered their next game ready to now, at long last, finally turn the tide of repeated failures and abject humiliation...

...and lost... miserably.

In the last panel Charlie Brown cries out, "How can we lose when we're so sincere?"

The answer is simple. They lost because the other team was better.

They lost because although they focused on the image of fairness, on their display of sincerity and sensitivity, and not on hitting the ball or catching the ball, or running the bases, the other team did.

They had put their efforts and time into their perception of a winning feeling and team spirit solely and did not pay any attention into the demand for winning skills. They filled their minds with wonderful affirmations but not the knowledge they needed to defeat the other team.

They should have spent more time pushing each other toward excellence, even when it was uncomfortable, and less time stroking each other to feel good.

Life does not award participation trophies and neither does the world of professional photography.

Professional photographers whose work is not exemplary, whose business acumen is not top flight, whose skills are not in a constant, sometimes grueling state of improvement, do not get any participation trophies. They get rejection letters, or worse, no responses at all.

Every photo student that comes through our doors enters an entirely level playing field. Every one of them, if their passion is sufficient to carry them through, has the real potential of becoming a truly great photographer. Where limiting physical characteristics are not at play, the concept of "innate talent" allowing for artistic mastery has been demonstrated to be largely a myth.[18]

If, and only if, they put in the dedicated practice needed and suggested by the instructors, over a long enough period, they can rise to the top tier of the pile and

[18] *Shenk, David, "The Genius in All of Us"*
 Ericsson, Anders & Poole, Robert, "Peak: Secrets from the New Science of Expertise"

become not just great, but also successful. But only a very few of them will.

That failure is not because of a lack of potential, it is because of a lack of effort.

It is often because, at some point in their "education" they were convinced that what was important was how "sincere" or "sensitive" they were, meaning, did they play nice in the sandbox. We "educators" have somehow convinced them that it was more important for them to be ever so sympathetic to the travails of others rather than to study and practice the techniques to *master* their own craft.

Unfortunately, the sensitive educational system is loath to accept that although there are few limiting physical constraints to learning photography, the actual *practice* of professional commercial photography, which can be physically grueling, is another matter entirely. I've personally known some truly frustrating situations where an otherwise very talented photographer simply could not perform the physically demanding tasks of the trade and had to drop out. In my opinion, the system that facilitated that scenario directly failed that student and did them far more harm than good.

Despite some old saying to the effect that they have all the time in the world, students have, in fact, a very limited and finite time to prepare; and every second of that time needs to be focused on hitting the ball not on their sincerity or sensitivity.

Some become failures because, for whatever reason, their victim mentality is so strong, so well developed and reinforced by their educational environment that they

cannot or will not refuse to be victimized by sleazy, bullying clients and thereby lose the respect needed to move up the ladder.

Some become failures because their education has managed not to instill in them the tools of winning but the attitudes of victims and losers, that *trying* is all that can be asked of them.

Remember Yoda's order to Luke, "Don't try... DO!"

But in the real world of professional photography sometimes even your best isn't enough and if you haven't, every time, given your constantly improving best, constantly working over your head and without a net, then you will fail. Period.

Fairness? Get over it.

We, as the teachers to whom they come to learn how to become professionals, do them no service if we coddle them through school and then dump them out, unprepared in habit or attitude, or even physical ability, into that meat grinder. The truth is, if we have done that we have both cheated them and lied to them... and then dumped them into a world that will most gleefully eat them alive.

A few years ago a student arrived in our program who was the nicest, most sincere person one could meet. But they just could not, for some reason, grasp many of the core principles, even of composition and basic ops. I asked the student multiple times if they had any interest in becoming a professional and was assured, over and over they did not: they just loved photography and wanted to get better.

I'd never met anyone with lower self esteem and so decided I could help that and tried to do that with encouragement, grades (the only "mercy" grades I ever have or ever will give) and it worked. They came out of their shell, the work improved slightly but enough to point to. Wonderful.

But unbeknownst to me, the student decided to go ahead and graduate and then go out and be a working photographer based on our encouraging words and praise. And then one terrible day the student came into the photo area, so angry they were crying and accosted me with the opening question: "Why did you lie to me?"

It turned out the student had taken their portfolio to a local outlet wanting to get hired and the potential client had no inhibitions about telling the truth of the quality of work, And it was devastating to the student.

How do you answer a question like that? I knew the answer but didn't know what to say. I do know I do not ever want to risk such a question again.

It is way beyond me how we can ever convince ourselves that we have done something good, simply because we had good intentions and were so nice and caring and oh-so-sensitive while doing it, when instead, like a good bellwether sheep, we have led them complacently and feeling great about themselves... to the slaughter. My mother used to tell me that, "...even nice doormats get walked on." But I do not see it as my job to create more doormats for the world of photo clients.

But that is precisely what we are being asked to do. If we were training loggers for the deep woods we would, in effect, be sending them into the woods with beautifully

polished hard hats and dull saws. We've sent our troops into the battle of their lives with shiny brass buttons and colorful medals for participation... but with no ammunition. We've prepared them to think that *feeling* good is better than *being* good. I cannot speak for all areas of endeavor, but at least in my discipline, the real world is ready to happily deliver some terrible news to them and then dance on the graves of their hopes and dreams and careers.

In the late 1880s a Paiute Medicine Man named Jack Wilson, who called himself "Wovoka" told his people, suffering under the truly outlandish practices of the BIA forcing them into conditions of squalor, that if they would but believe in his vision, dance the Ghost Dance and wear their ghost shirts, their dead warriors would return, the buffalo would come back, they would be impervious to the White Man's bullets, the white man would disappear, and the Indian people could reclaim their lands and birthrights.

So the desperate people made and wore their shirts, danced and danced, and began to feel positive about themselves and the movement and as it spread started to take a stand against the focus of the injustice heaped on them – the U.S. Army.

In December of 1890 200 of his last followers left alive, starving and near frozen men, women, and children, were surrounded and slaughtered at a place of infamy called Wounded Knee, South Dakota.

Like Charlie Brown, they may have wondered while being cut down, how could they lose when they were so sincere. They danced so well and looked so good in those

cool ghost dance shirts. But the almost ½-inch .45-70 rounds from government rifles hit them with over 2,000 foot-pounds of kinetic energy and were no more impressed by their targets' sincerity or shirts than will be the clients of photographers in the real world to unprepared students.[19]

Fair? FAIR??? Get over it.

CREDENTIALS Vs CREDIBILITY

In the world of photography and photo education there has been a long-standing attitude packaged as the brutal cliché that "Those who CAN do, and those who CAN'T teach."

But why would someone wanting to enter the competitive world of professional photography, especially in the day of the internet, be willing to trust their future to the ministrations and guidance of someone who has proved, in the market place of the real world, they cannot do it... no matter what letters appear behind their name?

Answer... they don't.

In the fine art world where talented artists are frequently ahead of the curve of public awareness and acceptance, they may appear as failures though history will perhaps prove that poor estimation to be wrong. Who, after all, is to tell an ARTIST they are not an artist?

[19] *Wovoka wasn't present at Wounded Knee. He had gone on to other things and died peacefully in 1932. Typical...The teacher did not share in the disastrous results of histeaching.*

In the professional/commercial world I'll tell you who... the client; the person with the checkbook.

In the world of professional photography, where the art, the craft, and the business sides must be wedded seamlessly, and success is quantifiable and measured in monetary units, the concern has validity and the client has the last word... at least in terms of there being a pay day. For educators, students are the real client.

And when free "education" from internet sources and books are increasingly seen as a viable substitute for traditional and institutional education because that traditional education is failing, that concern reaches a critical mass. Potential students would rather learn from someone with 20, 30, 40 years of actual personal experience than someone who has spent an extra three years studying how *other* photographers did it.

And yet, in spite of that, the system seems, when considering new faculty, far more interested in the right degree than in the right experience when it comes to hiring its professors. In light of all of the other influences on our current and future photo-educational world, that is a huge mistake.

In general, those who lived in the artificially safe world of modern academia from Kindergarten through dissertation and employment, protected by a strict code of practiced fairness and union protection, have been disabused of any real knowledge of what life is like in the tough, competitive world of commercial photography.

They may have read volumes written by others who were actually in the field and can parrot those lines perfectly, but they do not have the visceral "feel" of that

reality and so cannot pass it on. They have no real point of reference for what it is like to put your heart and gut on the line over and over, multiple times per month, perhaps per week, to put food on your family's table; to feel the sting and gut-wrenching sense of failure when you lose an important gig to a competitor who was just a little bit more polished in their presentation, when your "A+" work lost you the job to someone with "A++" work and that meant no movie that week or hamburger instead of steak and put-off needed car repair or perhaps dental work.

And the students, with far more insight than often credited to them, "get" it.

Students may be untrained and unprepared, but they are generally not stupid. Ours is a true *community* college, a center city school available to many students that would make the polite faculty of more rural schools quite uneasy. But many of our "kids" are only children chronologically. At an untenably young age many have, as the cowboys used to say, "Seen the elephant." And sometimes it came back for a closer look at *them*.

I spent half a dozen years on contract with the Denver Police Department to write, produce, sometimes shoot, and market law enforcement video training. I received several awards including an Emmy nomination for gang-related productions. I can tell you categorically those kids were largely uneducated but were *not* stupid.

They were, in fact, combat-bonded veterans with street smarts and well-honed abilities to read people... especially phonies. Their BS[20] radars were well

[20] *Male bovine excrement*

calibrated. And they completely understood that when the bullets started flying, looking cool was a fine thing but what mattered was hitting your target and not getting hit by them.

They knew that in the end, skill was more important than image. To put it brutally, it was more important to see the other person's blood than your own. They were children in terms of age. But when you looked into their eyes and heard them talk about life, it was clear that someone or some environment had stolen their childhood from them and thrust them into a hard world few adults from other more comfortable parts of our society could survive.

The sad thing was that those kids had zero expectations of a future. Their families and peers had, instead, filled them with expectations of failure, of virtual banishment into the ghetto or barrio world...or prison... or an early death. Their surrogate families, the gangs, offered support but it was a support for activities not designed to ensure longevity or a life free of confinement at State expense.

There is a devastating Heiku poem that perfectly reflects their state:

"A dying ember in the abandoned cat,
Love, and the need for love."

They were quite happy to make their time as comfortable as possible and enjoyed it when well-meaning folks tried to coddle them. But while they would take advantage of it and the momentary escape from the sordid nature of their reality, they laughed at the, to them, idiots, who just didn't understand.

They believed, as an article of faith, that true "fairness" was a myth, they understood as no well protected, well-meaning "normal" well educated and worldly sophisticated person could hope to, that at least at the moment, success for them in a world of finite resources was a zero-sum game and the idea of social justice was an oxymoron.

In their world of limited resources to give to one meant taking from another. That is pleasant for the recipient but is not justice by any definition, especially for the loser. Nevertheless, they much preferred the *taking* to the *giving up* side. What no one had ever done for them was introduce them to a larger world where a new factor, social productivity flowing from human ingenuity and innovation, could, if used wisely, fabricate, and supply the "Stuff" to level the playing field.

It is hard to grasp that brighter insight when your world is dark, dangerous, limited in both resources and intellectual breadth and dreams have died. In the throes of the industrial revolution and following the Great Depression, with unemployment rampant and bread lines everywhere, even thinkers like and following Marx missed that potential which, admittedly, was not very much in evidence at that moment.

But technology and education reignited it and out of those grim times the world took a massive leap forward. And surprise! It had not been a zero-sum game after all. Yet many of our students exist in a macrocosm of that time in history where there is precious little hope in their world for any gain unless it comes from the largesse, guilt, or vulnerability of someone else.

And yet, for a large percentage of the kids we worked with, all potential students, that dying ember, an unrealized (some thought unrealizable) drive for something better, could be fanned back into a real fire in their bellies. They were not lazy by any means, they simply saw no reason to indulge in pointless effort.

But when someone they accepted as "real" was able to convince them there was a way to turn that fire into a better life, into a better world for them, they, far more often than not, jumped into the process with a commitment and ferocity that was stunning. Once they understood that the resources to better their world could come not from taking them from someone else in a dangerous activity or from the public trough in a demeaning activity, but from their own efforts, talents, intellect, and commitment, they were all "in."

And it turned out they were good at it.

That internal fire is contagious; success – real success – is exciting and chemically releases far more serotonin and other endorphins than the phony success of participation trophies. It is a far better and longer lasting "high" than any drug can manage. What we as educators need to strive for is to tap into that fire and fan it into a flame of passion and commitment to success, not try to put it out and end up killing it with kindness and good intentions.

In our inner city and surrounding areas we have the same potential student population ready and hungry for it. The problem is they don't know it, and we are off polishing hard hats so the company workers look good... but we are not sharpening their saws.

When I was in high school I first heard the parable of the town sitting at the base of a very high cliff. The cliff was so sheer, and the rocks at the base so sharp that a fall was certain death. So certain, that it was a popular place for suicides; so popular that the town itself was beginning to get a bad reputation for not doing something about it.

The embarrassed town council fielded several proposed solutions including building a fence around the top of the cliff face that would keep people from getting to the edge. But the town finally voted to buy a new ambulance to cart off the bodies since that was a far more public display of their concern.

We invest in applications like TaskStream™ and demand data entry work from faculty on SLOs as our way of buying and then polishing the ambulance. And we wonder why people keep falling, or in our case, why state educational standard rankings keep falling. But we are so sincere...And that new ambulance is truly a beauty.

ECONOMY

Just as economic issues effected the business end of our discipline, so has it effected the educational component. It appears from countless speeches I've listened to that school administrators seems to believe -- and want us to believe -- that we lose students when the economy is good and gain them when it is bad. Alas, that is historically, statistically, and logically delusional.

Aldous Huxley wrote that we humans, "tend to believe what we tend to prefer." Many philosophers and

students of human behavior have expressed near astonishment at our proclivity to embrace the irrational in the face of solid evidence to the contrary because that better fits with our preferred narratives.

And to add to the confusion, the state of the economy is too often, and nearly always in academia, viewed through the filter of political leaning, never from an objective view. I wish they were right, outreach needs would be so much more obvious and easy to accomplish; but their measurement criteria suit only political preferences and not educational needs.

For objectivity and accuracy's sake there exist some far more objective measures. Gallup Poll's so-called "Misery Index" and the Bureau of Labor statistics showing the number of able bodied individuals not working have a much higher correlation to real world enrollment stats than the favored list of how many people have applied for unemployment benefits. And when all else fails one can take the apparently heretical step of actually talking to people "on the street" who are our potential student demographic. When one does that, a clear and incredibly logical picture emerges.

When one is scraping by, trying to put food on the table and hold on to any sort of roof and stability, there is no time and no money to think about discretionary school attendance (when they think that will always be there when more economically convenient) as opposed to spending every moment looking for work, or working hard and being glad to have it. When the economy is percolating along nicely, and discretionary time and money are available, it is *then* that people think

seriously about education and when we see our enrollment numbers increase.

PRE-EDUCATION and RE-EDUCATION

How old and sad – and accurate -- is the clichéd observation that "There is never time to do it right but somehow, always time to do it over." We can debate and discuss the lost productive time of that unfortunate truism, but in our case, we are not talking about just productivity, we are talking about lives and the finite time allotted to each of them. An old friend from a neighboring ranch and a western actor once said to me, "Partner, this ain't no dress rehearsal."

I'm not altogether sure we always understand that. We far too often, as the French visitor Alexis De Tocqueville wrote about us, "...act as if death were an option." And in doing so trivialize the damage done to students when we ill prepare them for their chosen path and do not force them to retrain properly when in some cases we need to explain to them why they should re-think this plan and go on to something else for which they now have the time and passion to learn and prepare.

But as shameful as our inactions are on that account, we have yet another issue of education to deal with: a pre-education in the face of modern anecdotal holdings that the education they can be offered through schooling is wasted time. In part we have been making that true, but it is time we stop and now work to convince our potential students we are back, serious, and ready to present them with education appropriate to their own goals and passions.

EDUCATIONAL STYLE AND APPROACH/METHODOLGY

In the disciplines where data does not change much, if any, over long periods of time, when, for example, the date 1066 AD has the same reference point today as it did 500 years ago, and hydrogen's place on the periodic table is pretty well secure and not subject to trendy chemistry, or where the speed of light is not dependent on where it is being taught, it may make some sense to measure faculty by the latest methodology and view class/course propriety based on its consistency over time. That I don't know. I don't have the luxury of working in such a stable field or environment.

Instead, our world of commercial photography is very different. It is dynamic, constantly changing in terms of styles and fashions even when technology is stable; but even more so now with technology in a state of pure revolutionary change. The photo "gospel" I taught in the early days of digital courses is utterly obsolete and irrelevant today. Virtually every year of this new century has seen major changes in critical procedures, processes, and scientific issues. If we attempt to follow the educational models that work for stable subjects, we *will* fail our students. Period... end of story.

The educational world is also a bastion of tunnel vision where, whether for issues of ego or turf or paranoia, professors seem to believe their domain owns specific processes. The world rushing at us makes such attitudes self-destructive.

As we'll see, what is needed is not greater inter-discipline competition but greater interdisciplinary cooperation; we need to be heretical, use innovation and creativity to think outside the box and across

95

disciplinary lines. We need some new tracks never needed before if we wish to be ready for our new world.

But that tunnel vision view of proprietary processes so deeply entrenched throughout academia will be one of the greatest obstacles to that success.

SOCIOLOGY AND (FUTURE) HISTORY

Sociology as an influence? Well, when it is tied to Technology, yes. During the industrial revolution, we ended up with a huge class of unemployed people who had not made the skills transition from an agrarian economy to an industrial one. The solution then was education. There was, in fact, work for them, but it was work that required re-education and in some cases re-location. It was difficult, disruptive... but doable.

But an increasing number of sociologists and historians are offering a devastating look into the future where a new brand of technology is headed our way, technology that does not require human aid or intervention, in which humans become, for many tasks, simply redundant and inferior to machine capabilities and which will result in a huge percentage of, in their words, USELESS people. What a harrowing and totally insensitive term; but it is one now being discussed seriously in some historical and sociological realms.

Yuval Noah Harari, a professor of history at Hebrew University, wrote, for "Ideas.TED.Com" on February 2017, the following:

> *"AI is nowhere near human-like existence, but 99 percent of human qualities and abilities are simply redundant for the performance of most modern jobs.*

For AI to squeeze humans out of the job market it need only outperform us in the specific abilities a particular profession demands… In the 21st century we might witness the creation of a massive new unworking class: people devoid of any economic, political or even artistic value, who contribute nothing to the prosperity, power and glory of society. This "useless class" will not merely be unemployed — it will be unemployable."

There is a critical line in there I want to repeat for emphasis:

"For Ai to squeeze humans out of the job market it need only outperform us in the specific abilities a particular profession demands."

We, the public, has been obsessed with whether or not a computer can ever be as intelligent as a human brain. But that is not the proper question. That AI 'creature' does not have to recreate all the power of the human brain to take our job. It only has to be better at the specific tasks that we were hired to do. Ask yourself, and be brutally honest about it… how hard is that to do?

In a Q&A session after his fascinating TED Talk on how it was *imagination* that allowed humans to ultimately rule the world as we have[21], he said it was possible that by the middle of this century, in the industrialized countries like ours, we could see a greater than 70% loss of available jobs across the spectrum due to robotics and AI.

[21] *Located on Youtube at https://www.youtube.com/watch?v=nzj7Wg4DAbs at 15:24 into the program. The whole talk is incredibly fascinating but it is his answer to a question at the end that is chilling.*

In a May 2017 article in "The Guardian"[22] Harari explained that as technology starts replacing us,

> *"...The crucial problem isn't creating new jobs. The crucial problem is creating new jobs that humans perform better than algorithms. Consequently, by 2050 a new class of people might emerge – the useless class. People who are not just unemployed, but unemployable"*

Oxford Researchers Carl Frey and Michael Osborne wrote a publication on future employment[23] in which they surveyed different professions and concluded a high likelihood of their takeover by AI. They estimated that:

> *47 percent of US jobs are at high risk. For example, there is a 99 percent probability that by 2033 human telemarketers and insurance underwriters will lose their jobs to algorithms.*

> *There is a 98 percent probability that the same will happen to sports referees.*
> *Cashiers — 97 percent.*
> *Chefs — 96 percent.*
> *Waiters — 94 percent.*
> *Paralegals — 94 percent.*
> *Tour guides — 91 percent.*
> *Bakers — 89 percent.*
> *Bus drivers — 89 percent.*
> *Construction laborers — 88 percent.*
> *Veterinary assistants — 86 percent.*
> *Security guards — 84 percent.*
> *Sailors — 83 percent.*

[22] https://www.theguardian.com/technology/2017/may/08/virtual-reality-religion-robots-sapiens-book
[23] *http://www.oxfordmartin.ox.ac.uk/publications/view/1314*

Bartenders — 77 percent.
Archivists — 76 percent.
Carpenters — 72 percent.
Lifeguards — 67 percent.

Those numbers are terrifying and will have a major effect on the political-economic environment. That will most certainly effect professional photographers whose income depends on servicing many of those soon-to-be defunct jobs.

The Frey/Osborne prediction is for the year 2033 or roughly 16 years from now. A child born today may be facing a future where there is no work of any kind available for them. [24]

Let that sink in for a moment.

If our students are to have ANY kind of job they will have to totally stand out from the crowd. Our jobs as educators are to help them do that. And we don't have much time to figure out how to do it.

WHAT IS AT STAKE?

If I am to succeed at my role as a still photographer or video producer I must ultimately make enough money to support myself and family. To do that I must succeed first at meeting the needs of my clients by creating marketing content that helps them sell more of their product or services.

[24] In the Guardian article mentioned above, it is suggested that to control the vast number of "useless" people, the authorities will need to create a universal minimal wage on a survival level and then keep the people satisfied with virtual reality games to create the sense of enrichment and "Self actualization." Sorry, in my opinion that now is a dystopian view of the future a la Orwell but it is not science fiction anymore.

If I fail to accomplish that, I am out of a job and a failure. Worse, that art director or marketing director I failed will tell their colleagues about it at their monthly schmoozers, and my name as a failure will spread like wildfire even in a fairly large market... and my business phone will go as silent as the grave to which my career would be headed.

But what is really at stake? Honestly, how important to the value of the culture or cosmos is my helping to sell one more muffler or one more suit? The truth is... not very. My OWN future may be at stake with its own high level of importance to *me*, but at least I had my shot... I can legitimately ask for no more. The result is on me.

But in my role as a teacher, what is at stake is the success and futures of those in my charge to finish the program and enter the world in my stead and be successful at it. The needs and the criteria for success are easy to define and measure. And they do not include any concerns for warm and fuzzy feelings.

Remember I said in the introduction that I was told as a kid that when you are in a hole to stop digging. Well, we in education are in a hole of our own making. You wonder why enrollments are down? Look to some inconvenient and unpleasant numbers and let's put them in perspective.

Would you, for example, rush to employ a financial advisor whose earnings numbers were in nearly constant decline? Of course not. Would you hire a plumber whose Yelp ratings were low and going lower? I'll bet not.

Think what sites like Yelp and "Angie's List" have done to actually improve home services because people now can easily see reviews, recommendations, and rankings from real customers and weed out bad ones.

So take a look now at the educational rankings of the various states in the country and, for that matter, the country itself – OUR country – among other industrialized countries and ask why would a potential student who was aware of those numbers choose to "employ us" to prepare them for their futures? It doesn't matter if it is even free if it is not likely to give them what they need. If it is unsuccessful the value of the spent time will be more of a loss than any small fee.

In the 2017 U.S. News and World Report, California is ranked 3rd for upper level education.

Great.

Really? Look deeper.

That ranking is based entirely on those who graduate with a degree. In terms of the category of "Educational Attainment" we are 20th.[25] We are ranked 42nd in terms of high school graduates. That significantly effects the college level numbers. Ranking 3rd with low numbers of enrollees and graduates is not a very good number. And number 20 among the states is worse.

The U.S. is at or below average IN THE WORLD according to a 2017 study by Pew Research. Those are not numbers to be bragging about. Nor are they numbers to attract students who may be more aware

[25] https://www.usnews.com/news/best-states/rankings/education/higher-education

than we are about their need to stand out if future success is a goal.

Students do not have to like us as individual instructors; but they need to respect us if we expect them to want to come to and sometimes endure our classes because they believe that in the end their future will be better assured by the experience.

I would rather have my students all be in a state of near mutiny but know, when they complete a course, they can do the work on a level that will be required of them by future clients.

To continue as we have been, is simply another shovel full removed from our deepening hole. To change those numbers and to change the attitudes of potential students to make them thrilled at the idea of coming to our classes, we need to stop digging in the same hole. We have to quit thinking that the solution is simply a shovel with a different shaped blade... or better still, a power shovel.

I do not know about other fields, but in my field, practitioners do not succeed by *feeling* good about themselves, they succeed by *being* good at what they do and, amazingly, when that happens *then* they feel good about themselves and rightly so.

Kids are smart; they know when they are being lied to even if it is about their own work... even if they like the lie, they often feel cheated by it... as they should.

If you want to grow and be up-to-date in my field, then you must be able to read the literature containing the new advancements. That is straight-forward enough;

but there is a problem. That literature, especially the parts containing the technical stuff you must know and understand now that we are so tied to the computer and technical world, is written in three languages only: technical English, technical German, and technical Japanese. But technical English is fast becoming the "*lingua Franca*" of the industry.

Any program or set of courses that allows our students to avoid learning that difficult variation of an already difficult language, especially if you did not grow up speaking it, is doing them harm, not good.

English, just ordinary conversational English, is a very difficult language to learn for people whose native language is almost ANYTHING else. Most languages are far more structured and rules-compliant where English, by comparison, is often a linguistic crap shoot.

And *technical* English, with the combination of conflicting jargons, innuendos, and "terms of art" often borrowed (badly) from other languages and of the various fields, is just insanely difficult.

But it is an absolute necessity for working in this already competitive world and anything a school does to allow students to avoid the hard, boring task of learning it, may make them feel good now but at the inexcusable cost of failure later.

Academics pursuing issues of "equity" and "fairness" push back hard and say it forces additional requirements on some of our students and that is not fair. Well, yes it does and no it isn't.

I was not consulted in the making of the "rules" by which our field operates and have no say in changing them. I have a choice, however; accept them and succeed... or fight them and fail.

Sun Tsu, in the "Art of War" said the wise general only voluntarily fights the battles he has a chance of winning. This is not such a battle.

We cannot change this reality, we can only change how we deal with it and what we do to make it work for us and our students rather than against us... and against them. Perhaps on their birth certificates there is also a warranty card to assure life's unending fairness. If so I'd like to see one; perhaps it lists where I can get one since mine seems to have come unattached to my own birth certificate and lost and I'd sure like to get a new one.

Even artists, as adults, tend to think in words more than images. Modern cognitive science studies have shown clearly the effect on cognition and perception of one's vocabulary. Bluntly put, if you don't know the word, you don't know the concept.

Our faculty might deliver the greatest lecture since Socrates, the most brilliant presentation ever made and make Demosthenes weep with envy, filled with profound insights, glorious analogies, and deep revelations into our discipline; but if our students do not know enough of the words specific to the topic, we might as well be talking to the wall.

Yet we are getting more and more students passed through to us from inner cities High Schools who read barely at a comic book level, have only a marginal and highly politicized knowledge of history, no knowledge of

civics, no knowledge of geography, minimal knowledge of the science and technology and math that underpins our discipline (that I learned in high school and even junior high).

Nor, in far too many cases, can they predictably string together a paragraph of declarative sentences in proper English or demonstrate sufficient critical thinking to turn in a one-page review of a local museum show showing any real understanding of the work they are seeing.

It's not their fault, they have been failed by the system.

With state educational rankings that I'm told once were the poster child for educational excellence now plummeting and at the bottom half nationally, the digging in our hole continues. What ought to be taking place is a concerted effort to look back at that time when we *were* at the top and re-examine what we were doing THEN. Instead, we keep coming up with new methodologies (excuse me, pedagogies) to change the trend.

I keep hearing apologists reiterate that, well, we can't do that because times are different now than they were then. My question then is, so how is that philosophy working out for us? This paper is not specifically about fixing the broader educational system, though it needs it badly. It is, rather, about fixing that part of it that directly impacts our professional photo program and that is a situation in desperate need of being addressed and solved.

But we do not operate our program in a vacuum; we are part of that broader system so what it does cannot fail

but to have an effect on us. When they see us as just another program to be treated like all the others it can be devastating to us. When they ask us to act as if we were one of those never changing academic courses it creates an impossible situation for us.

A workable approach whose main goal is to get students to graduate and transfer to a 4-year school is not a workable approach for vocational classes whose main goal is to turn out students ready to enter not more schooling but real work and the real world.

The current approach is not working, and the easily predictable result is just a continuing slide to the bottom. The educational rankings are not numbers well calculated to establish any bragging rights. Since the numbers are very public and easy to find online, how is it we keep either ignoring them or continue the process that facilitates the slide and continues making our hole even deeper?

It would be both impolite and impolitic to say we – the educational system – are stupid. But it seems inescapable to note that we seem, collectively, singularly incapable of learning from an educational experience ourselves and keep repeating the failing exercise like the "Energizer Bunny" pounding on its drum.

That puts us and our program in a bind because when the students leave here, in addition to having to be able to learn from technical papers they probably can't read, they will have to write professional and polished proposals in impeccable business-grade English if they want the plum jobs where the money is… which they probably cannot do either.

They will have to do their own business accounting until their success will afford a good CPA, but new math has left them unable to count change or do basic math in their heads and without a calculator. If I submit a proposal to a client that includes several budget line items, and the client wants to know what it will cost if we skip items 3,6, and 8, I need to look at that and give them at least a good "ballpark" answer without resort to a calculator.

The system as presently configured cannot – or will not – provide that level of education. There is another shovel full digging our hole even deeper.

To meet our mandate as an applied program we have easily four or five years of material to cram into the two and sometimes three years we will have them in a community college, which leaves us *no* time to bring them up to speed AND give them the working knowledge needed.

So we have to choose, all too often, to do the basic level stuff like ENGLISH AND MATH at the expense of the topic. Because if we don't, we sometimes cannot present the topic in language they can understand and use. Another shovel full... maybe two or three in this case.

At yet with the failure of high school education we expect them upon arrival to know and declare what they want from their higher education when they walk through our doors, as if more than 2%-3%" of High School graduates ever really already knew and do not change their life's goals at that point. But then they are punished with registration positional loss when new

insights (what used to be the goal of college) indicate a change or are forced to stick to a bad plan.

This does not serve the students or the process of education. So who does it serve? Simple deductive reasoning would look to see who is left in the equation... but we don't teach that anymore either. I guess that is good because it protects the person who came up with that less than brilliant plan. Another shovel full.

The State operates a top-heavy system where, for example, Dean positions of indeterminate value are created and needed classroom positions go unfilled. We let the Union bully us into protecting deadwood that we all know exists, including faculty that may be brilliant but cannot be understood by the students. Another shovel full.

I come from a completely practical world where, as noted, one succeeds by being good and relevant at the tasks for which we are hired... or we fail. Period. No middle ground exists, and no excuses are accepted. If students are to succeed they need to be prepared for that world. And their educational environment ought to model it for them.

A career in that unforgiving work environment, which is also the one we are allegedly preparing students to enter, has led me to consider sacred cows as one of my favorite meals. Given the poor starting point and the hobbled time constraints, we do not have time to indulge in entitled cattle blocking the road; we need to sweep them aside. If I have to be a bit hard edged to get the attention we desperately need, if I need to maybe shoot

one of those cows in the street and have it for lunch, then so be it.

So here is one of those local sacred cows now... metaphorically we do not need a Dean of Student Equity; we, however, desperately need a Dean of Student *Excellence*.

If we do not pursue *excellence* in our students, recognizing that, in fact, we are NOT all equal in terms of intellectual experience and capacity or physical abilities when they hit higher educational facilities and develop courses, programs, activities, etc. to bring them UP into a common level of excellence, not lower them to a common level of mediocrity, then we have failed them just to make ourselves feel good.

Oh wait, here's another cow that just wandered into the road... We don't need a Dean overseeing a strong and unified faculty, we profoundly need someone overseeing a *great* and talented faculty. If we cannot demand such excellence of ourselves as faculty, from where do we get the gall to pretend like we have any right to expect it from our students?

In our discipline specifically, we need to start getting our students ready for that tough real world by building the habits of passionately pursuing grueling hard work with long hours in an excuseless environment while it risks, for them, only a grade and not their future success or failure.

We need instructors who can not only hold their students' feet to the fire and noses to the grindstone but who can help them see and start experiencing the rush and joy that comes to all artists when their work really

connects with clients and collectors. That makes it all worthwhile, but the results do not come without the effort and commitment.

The world of professional photography is littered with the virtual corpses of incredibly talented people who were never made to develop the ferocious work habits needed, never learned the protocols and etiquettes of the business, or how to even talk to a client in a business manner.

And those that fail, not only fail themselves and maybe their futures, if they were one of *our* students, they also do our school and program no good when they tell others where they went to school... and learned how to fail.

We want the Photo Program at San Diego City College to be the best, period. That is our mission statement. But sometimes being the best means being the hardest. In the work field it means consistently working to go beyond what is simply asked of you and often beyond the best ability you started with that day.

We do not exist as teachers to be students' friends. We exist to push them to their limits and beyond because that is what their field will demand of them. We are at our best when we can help make them the very best they can possibly be. The real question, for this section and ultimately this document, is, does the college and district want us to be the best? And if so, will they help us do what it takes?

The fear is that such an approach would result in a drop of enrollment, and in the short term that is likely true. The "weeding out" process is always traumatic for students used to an easy grade suddenly asked not just

to perform, but be constantly pushed to perform at their best level all of the time. But in the end, students are attracted to the schools they think will best prepare them to excel in their chosen field.

In the field of professional photography, that should be – and *could* be -- us. And if it is not, sitting in the best facilities possible and with a solid faculty, we and our administration will have a lot to answer for. It's like the old saying, "Ships are safe in the harbor... but that's not what ships are made for."

Part Two: SURVEYS/INTERVIEWS and RESULTS

Of course, whatever I write that runs contrary to the State, District, or School's views is easy to dismiss. After all I have a vested personal interest in the success of our program that may not be shared, especially if it is in conflict with the latest pronouncements from the educational throne. Who am I, after all, to dare to question those well over my current pay grade? That I spent a lifetime in that field is irrelevant to most academics since it was only in the (to them) intellectually challenged vocational realm. But there are sources of relevant information that are not dismissed so easily.

As happens in so many areas, real insight comes from following the money. Who is it, then, that has the greatest risk involved in trying to see into the future of photography... apart from students? Students are only risking their future, no big deal to state-level administrators; but who is risking large sums of money on the prophesies of that future?

The answer is, it is the manufacturers and retailers in the photo industry. It takes time, money, energy, and other resources to design and manufacture new

equipment whether that is a new camera body, a new lens, or even a new type of sensor or internal processing unit. Their abilities to research industry trends far exceeds mine. Once that decision is made, a vast amount of money is spent on prototyping and then manufacturing a reasonable quantity to put on the market all before a single dime in revenue is realized. Now THAT defines "risk."

And the retailers too will be investing large sums in inventory commitments again, long before revenues start to appear. These institutions risk money AND the continued existence of their businesses on their prophesies for the future, therefore it seems logical to ask them what *they* think about it. So that group formed my primary target universe.

SURVEY/INTERVIEW UNIVERSE

I was able to interview and/or get responses from the following companies' reps:

- Panasonic/Lumix (Equipment manufacturer)
- Olympus (Equipment manufacturer)
- Canon (Equipment manufacturer)
- Tamron (Lens Manufacturer)
- Sigma (Lens Manufacturer)
- Sony (Equipment Manufacturer)
- NelsonPhoto (San Diego Photo Retailer)
- George's Camera (San Diego Photo Retailer)
- Adorama (New York Based Photo Retailer)
- Samy's (Los Angeles Based Photo Retailer)

This represents a cross section of manufacturers and retailers on multiple levels and in multiple locations. I

also asked professional photographers in San Diego, Houston, Denver, Santa Fe, New York, and L.A. for their input and feedback.

So what were the questions?

SURVEY/INTERVIEW QUESTIONS

Below is the questions asked of our survey takers or in more casual interviews.

GENERAL QUESTIONS

1. What category best describes your Photography involvement?
 1.1. = Advanced amateur
 1.2. = Intermediate Amateur
 1.3. = Novice/beginner amateur
 1.4. = Student in Photo course/program
 1.5. = Photo Educator High School or College level
 1.6. = Working Professional Photographer
 1.7. = Photo educator AND working photographer
 1.8. = Manufacturer of Photo Equipment
 1.9. = Retail Sales of Photo Equipment

2. Do you currently work in film or digital?
 2.1. = Film only (100%Film - 0%Digital)
 2.2. = Mostly Film and a little digital (>75%Film - <25% Digital)
 2.3. = Fairly even mix of Film and Digital
 2.4. = Mostly Digital and a little film (<25%Film - >75%Digital)
 2.5. = Digital Only (0%Film – 100%Digital)

3. How long have you been involved in Photography?
 3.1. = Brand new to it, less than a year
 3.2. = 2-5 years

3.3. = 6-10 years

3.4.= 11-20 years

3.5. = more than 20 years

4. In the next 5-10 years do you see video and motion capture being incorporated into professional and commercial photography including wedding/event photo?

 4.1.= no, not at all, it will remain a separate discipline

 4.2.= maybe a little bit

 4.3.= Video may make up to half of the professional work

 4.4.= Video and motion will make up more than half of all professional work

 4.5 = Video and motion will take over almost all still photo work

5. Do you currently provide Video as part of your work product/services?

 5.1. = none at all

 5.2. = a little bit

 5.3. = About half still and half motion

 5.4. = mostly video

 5.5. = all video

6. Should Photo education incorporate commercial video production into their programs?

 6.1.=No they should stay with stills

 6.2.= Maybe they should add a special survey course on commercial/corporate video

 6.3.= They should be increasingly adding commercial/corporate video to keep up with the market

 6.4.= They should be moving toward being primarily about motion and video commercial work with some still-based education

6.5. = Stills are dead, they should concentrate on video and motion capture

7. What disciplines/genres within Professional Photography do you think are going to be the most impacted by new technology? (Please rank in order from most impacted to least impacted)
 7.1. Photojournalism/Documentary
 7.2. Portraiture
 7.3. Fashion
 7.4. Commercial/Advertising
 7.5. Wedding and Event photography

8. Are there other technologies (in addition to video/motion capture) you foresee impacting the world of professional photography and image making in the next 5-10 years? (Check all that apply)
 8.1. = Virtual Reality/Augmented Reality
 8.2. = 3D/Stereo
 8.3. = Cell Phones
 8.4. = Quantum computing and storage
 8.5. = Greater resolution via larger format and/or smaller pixels
 8.6. = Lens/optics designs and capabilities
 8.7. = All of the above

9. In what part of the country are you located?
 9.1. Upper east coast and New England
 9.2. Middle Atlantic
 9.3. South Eastern US
 9.4. Gulf Coast
 9.5. Midwest
 9.6. Rocky Mountain West
 9.7. Southwest
 9.8. Northwest
 9.9. California

For two of the categories of respondents I added a specific additional question.

SURVEY QUESTION SPECIFICALLY FOR PHOTO EDUCATORS

10. With the availability of online tutorials and materials what is the place for traditional classroom-based photo education going to be in 5-10 years?
 1. it will be completely irrelevant having been taken over by online learning
 2. Mostly online material would some specific classroom materials/activities
 3. An even mix of classroom and online materials works just fine.
 4. Some online is fine but it should be mostly classroom.
 5. Classroom education is still the best due to the dynamics and interaction between teacher and students and between students

SURVEY QUESTION SPECIFICALLY FOR PHOTO MANUFACTURERS

11. What do you think will be the major technological impact on professional photography in the next 5-10 years? (Check all that apply)
 1. Video and Motion Capture
 2. Miniaturization
 3. Automation and AI of camera functions
 4. Combining technologies and functions like cell phone
 5. Greater resolution
 6. Mobile and remote connections such as WiFi

SURVEY/INTERVIEW RESULTS

Here are the summarized results of the surveys sent out based on the questions noted above.

What category best describes your Photography involvement?

80% Manufacturers of photo equipment and supplies

15% Retailers of photo related equipment and supplies

05% Professional working photographers

NOTE: As I mentioned. it became apparent to me that the best information would come from sources with the greatest economic interest in the answers, so I concentrated my attention there. I also spoke more casually with a number of educators in photo programs around the area and in my home state.

Do you currently work in Film or Digital?

For the manufacturers and retailers, the question was somewhat irrelevant in terms of working with the gear. However most manufacturers of camera bodies were heavily invested in digital with, in a few cases only, some film products. There are still some small niche manufacturers who cater exclusively to the film world but none of the major entities I spoke with did that because they did not have a customer base to support it.

For the working photographers, only one I spoke with "occasionally" shot film on request but the others were working 100% in the digital world.

Actually, ASMP (American Society of Media Photographers) statistics say that perhaps in some venues and genres as much as 3-4% still occasionally provide film-based products.

There are also some 'fine art' practitioners who cling to film capture but none of the working professionals I personally know or interviewed/surveyed did. Many bemoaned its loss but not enough to return to the issues of time and cost when, in their opinions (and apparently those of their clients) digital is a very viable qualitative match. It is simple economic logic, if the competition got better results shooting film, that is what would be demanded across the board.

There is, however, a much higher level of interest among photo *educators* to remain attached to film than is reflected in the commercial/professional world. Some seem to think that "art" is a function of effort (a view not shared in the traditional fine arts) or that the imposition of "the machine" into the process diminishes the artistic characteristic of the final piece.

That is strange because traditional artists believe the final image itself is the one and only proper indicator of quality, but how it was generated is irrelevant. Early photographers sprang from those traditional ranks. Artist Lazlo Moholy Nagy, one of the founders of the famous "Bauhaus School of Design" which influenced art and graphic design for decades, wrote that it seemed to him that it was indispensable that the artists of 'today' go to work with up-to-date means. His attitude would be readily accepted in the working

world of professional photography today... but less so in academia.

Other instructors believe, I think correctly, that using film as an *introduction* better demonstrates and explains the way the medium works though they understand the working world is a digital one.

A few understand that it is increasingly a world including motion capture and output.

How long have you been involved with Photography?

This question was designed when I initially expected to survey a much wider group of individuals. Manufacturers like Canon and Tamron have been around for decades. So have the retailers. The working photographers ranged from old timers like me that have been in the business for 40+ years to relative new-comers with 10-20 years' experience and less. Some of those who were true newcomers, under 5 years in the field, had, except in school, never even held a film camera.

In the next 5-10 years do you expect video to be incorporated into professional work?

Now we are getting to the heart of it. Most respondents pointed out that it already is a significant portion of their work load but that it will simply continue to grow in importance. New video technology is already being poured into

121

cameras and several felt that before long the video side would be driving the still functionality, not the other way around.

Technology had already evolved to allow digital stills to compete qualitatively with film-based output in virtually all areas of importance, from detail and resolution, to dynamic range and tone capture, to color fidelity, and now to archivabilty.

Unnoticed by many, but there In the background, video technology is right on track and snapping at its heels. And once still frame grabs from a video stream can match the same shots from a digital still camera all bets will be off. That is here now but the pro digital cinema camera that can do it are not very convenient to use as one might a still camera.

But that too is changing and it is estimated will be accepted and common in no more than 10 years and more likely in under 5 at the current rate of development.

Do you currently provide video services as part of your normal offerings?

This question was directed at working professionals. Almost 80% said that they were being asked for video services by their clients. Some tried to provide video themselves and were trying to learn the intricacies and mental/mind sets of the motion world as best they could while others decided the best approach was hiring

competent video creators and video producers to work with them.

Almost all of them felt this was the wave of the future for them and one way or another they were going to have to deal with and learn at least enough to be able to lead a creative team that included motion with still capture. Many bemoaned there was no courses to help them learn the aesthetics and techniques.

Even in the video world itself, there was an uptick in the sales of "video stock." Stock images was previously largely the bailiwick of still shooters and was, for many, a significant source of income. Now with the increase of amateur and independent self-proclaimed "filmmakers," the use of high quality clips to increase the apparent production values of a project is also on the increase.

Just as, in the past, still photographers would often finish a paying job and look for other images they could provide to a stock photo company – or sometimes just go out and purposefully shoot for "stock" – now video shooters are beginning to do the same thing.

All this is made possible because of the internet and the ease of viewing potential clips from anywhere and the ease and speed of simply downloading them in the needed resolution.

But to be fair and include all responses, about 3 out of the 18 that I spoke with or surveyed felt they could hold out only providing still services

and hire video production when it was needed. We'll see... The defining answer will come from economics.

Should Professional Photo Education incorporate Video into its Curricula?

That was treated as a sort of "Duh..." question. Several were surprised that at SDCC, with a reputation as one of the premiere commercial/vocational photo programs, did not do so already. There is not much more to say here... the answer was overwhelmingly, YES!

To be fair, there were a couple of die-hard antiquarians who insisted that digital itself was a fad and would die as we came to our artistic senses and returned to "real" photography and film. For them video was like technology from Star Trek.

What photo genre are likely to be the most impacted by this new technology?

I asked them to rank the optional answers.

1. The result was a virtual tie between **wedding and event photography** and **advertising/commercial photography**. Wedding photographers have a major head start and have been including video for years. But due to the cost of video equipment and production it was largely limited to high ticket weddings.

Similarly, in the commercial world, corporate/industrial video has been around for years (I produced my first industrial video in 1983 and was not breaking any new ground by doing so) but in both cases the video side and still side were really seen as separate issues. With only a few exceptions, "back in the day" the still production and video production portions of the project were undertaken by two different producers or production companies working under one or the other as leads depending on whose "gig" it was (i.e. who was actually working directly for the client) with the other working as a sort of sub-contractor.

While I listed it separately, **Fashion** is seen, in this context, as a subset of the advertising/commercial genre and video was initially done a lot but by different companies/providers. We may commonly think of it as a type of portraiture, but its business model is very different and more in line with advertising/product photography.

What has changed dramatically and across all these disciplines, is that increasingly it is the SAME production company that is tasked with creating BOTH the still and the motion components of a project for their clients.

2. **Photojournalism** (including sports photography) and **Documentary** have had still and video exist side by side though documentary has been, with

the demise of feature magazines, almost exclusively the result of filmmakers.

It has to be noted however that news/sports shooters and documentary filmmakers create products that are very different in type, purpose, approach, methodology – essentially in all ways other than coincidentally using similar cameras – than the type of work for which our program is training students. That journalistic/ documentary approach falls generally under the auspices of, in our college's case, the RTV (Radio and Television) program though in many private schools instead of separate programs in different departments, the image-making courses we provide under the photo program, the journalism program, and the RTV program are much more closely connected and sometimes provided under a common umbrella department or "school" that is more cooperative than competitive.

However as a side note, as still and video technology are beginning to merge, both photojournalists, sports shooters, and some (but few) documentary shooters are using crossover equipment designed initially for still photography.

3. **Portraiture,** in its more traditional form is still almost exclusively the work of still photographers. However, one area of vulnerability to video specifically is editorial portraiture. As print-based magazines are starting to fall by the wayside in favor of online version, the ability to include motion-based clips is allowing for more

126

interview-style and action oriented graphics in place of the traditional portraits and PR headshots from the likes of Karsh, Halsman, Newman, etc..

The caveat here is that most wedding photographers ALSO offer portraits such as bridal portraits, engagement portraits, etc. so as portrait photographers are being backed into video whether they are ready or not.

4. The overlooked genre was **Landscape** and **Fine Arts** work which apparently the respondents did not see as properly commercial or professional. But if the photographer intends to earn a living or at least significant revenue at it, it becomes, like it or not, as commercial as any of them just with a different business model. That, at least, is the way we teach it, as simply another commercial genre with its own set of cost centers and revenue streams. And as such it too is being impacted by the changing times. For example, the interest in "Stock" video is increasing rapidly in the same way as stock still images have traditionally existed.

What other technologies will have an impact on professional/commercial photography?

Comments reiterated that video was number one. But right on its heels were technologies that resulted from miniaturization such as cell phone, and those enhancing mobile apps and WiFi use.

As cool as AR/VR/3D and 360 can be, the down side is a flipped perspective on the good side: the required audience participation and the need for the audience to do something special such as wear special head gear or goggle-like viewers was seen as seriously limiting.

Consequently, while powerful in some applications, as a general industry driver and something powerful in education, they took a back seat in the professional world. They weren't off the bus entirely but not a major concern.

Packing more but smaller pixels on a chip would continue as a trend but by themselves did not really change much relative to how professional photography was performed or taught, at least fundamentally. The same with lenses; yes, lens technology had to keep pace with the increasing demands of smaller photo diodes but that was no different in terms of shooting needs than talking about finer film and lens development over the years to reduce flare and distortion.

Another unexpected losing trend was the move to larger format digital. The reasons given were twofold: the lack of need (given the increasing sensor capacity of standard 35mm-sized camera bodies) and the continuing exorbitant equipment cost overwhelming the minimal gain. Last year I completed a series of portraits of veterans for a show using my Canon 5DSr, a 50 megapixel DSLR. The show called for 20X24 prints and the results were as good as any similar portraits I had previously done with medium format film.

Commercial clients, aware of the benefits to their photographers, are demanding more for less. For the photographer interested in their own profit position, extreme expenditures only make sense in the few niche arenas where that extraordinary quality is still demanded. Even so, many photographers cited the ability, in major venues like near NYC and LA, of simply renting the costly equipment if it was needed; but even that was decreasing.

The potentials of quantum computing are fascinating but, with the possible exception of storage issues, it appears farther down the track in terms of general consumer availability than would reasonably drive educational impacts. But that's what was said about automobiles, TV, computers generally... But... But...

The current wisdom is that even when it becomes viable, it will be a large influencer of equipment *design* but not of equipment *use*. Really?

Consider this. Several companies including Google and IBM are currently racing to be the first ones to build a working quantum computer. Why? Because it will be to a current computer, even a current super computer, as a super computer is to a slide rule, it will change the world the day it goes becomes publicly available.[26] A quantum computer does not use "bits" based on transistors that are either in a state of on or off, it uses

[26] https://www.wsj.com/articles/how-googles-quantum-computer-could-change-the-world-1508158847

"qubits" that, in contradiction to every bit of Newtonian world logic, are in BOTH on and off states at the same time.

There are some great explanations as to how this all actually works[27] but the point, for us, is that when quantum chips and small CPUs become available for camera uses we will end up holding a device that can not only DO almost anything by itself, it can think faster than we can and store virtually every iconic photo ever taken to use as comparisons to set itself.

How can that not have an effect on its use?

In what part of the country was the respondent located?

I asked this question because I thought it might make a difference in the answers depending on where the business or individual was located. It turned out to make essentially no difference. In retrospect it is obvious: the influences are coming from all directions and impacting photographers and manufacturers alike. The internet has seen to that. Regionalism in everything from style to jargon is slowly disappearing.

What is the place for online photo education?

Wow, here was a unanimous response. Every single photo educator I spoke with or surveyed

[27] *https://arstechnica.com/science/2010/01/a-tale-of-two-qubits-how-quantum-computers-work/*

absolutely hated trying to teach ANYthing demanding creative projects purely online.

Everyone felt that the important dynamic of classroom participation was lost and that despite how it might seem in some disciplines, all those actually teaching interactive subjects online -- including me -- were spending significantly greater amounts of time (up to three times the amount of time) trying to simulate that classroom experience than we were spending in the classroom itself.

However...

Everyone on the college level also thought, despite their otherwise negative view, the writing was on the wall. When economic issues outweighed educational issues, as is certainly the case in California but also a problem in many other venues, the only way to reach newly mandated enrollment numbers is to offer the online courses.

They are popular for "intro" levels because students flock to them until they realize what they are losing if they also take an instructor-led class. So, for all the wrong reasons, instructors felt that it was inevitable that online classes would soon be a part of their school's curricula. And across the country the course list is growing rapidly.

The problem all of them teaching creative subjects faced and to which all were seeking solutions, was how to recreate the dynamic of the classroom, especially when it came to necessary class

elements such as critiques where normally everyone participated. I talked with faculty using a broad variety of OLS (Online Learning System) applications and none felt they really had succeeded in properly recreating that important classroom element.

Manufacturers' view of major technological influences and trends.

It turns out this question was asked and answered some time ago in the industry and we in academia are coming late to the table. However, the answers varied a little with the brand's existing customers and their view of their place in the litany of types of equipment... but there were a few exceptions.

NOTE: All manufacturer's reps were extremely cautious about giving away company secrets and plans that, if made public, might aid a competitor. So they tended to stay on pretty solid if sometimes vague ground that was fairly well known across the industry.

Olympus made the decision early in the century that they would stick with smaller, lighter equipment in the digital "micro 4/3" (said as "micro four thirds") format. In some ways that decision backed them into their target demographic of travel photographers and entry level photographers.

By keeping a close watch on their base and not expanding into the territory already well staked

132

out by others, they have remained quite viable. But quietly, they are concerned with some new competition such as from **Panasonic/Lumix** that uses the same format (Micro 4/3) but have openly embraced video capacity in cameras such as the GH5.[28]

For many, the GH5 is itself a game changer: beautiful stills for travel and sports needs, high end video, and a magical "pre-burst" setting that captures, at video frame rates, 30 frames before and 30 frames after the shutter button is pushed to avoid missing critical moments of action.

Both **Sony** and **Panasonic** have always been involved in high-end broadcast and professional video and are well grounded in that technology. After Sony bought out Minolta their still camera line expanded and now includes high quality video capability.

Sony's pure video lines go from consumer grade "handy-cams" to semi-professional and professional shoulder-mounted broadcast cameras for TV and ENG (Electronic News Gathering) use to full-on digital cinema[29] cameras.

[28] *No one from Olympus told me this but I would be surprised if, in the next year or so they did not field a camera to compete with the GH5. Video is gaining too much ground too fast to ignore for long.*

[29] *"Digital Cinema" is a relatively new term that refers to video-based cameras of a quality that can produce output suitable for display in a typical large screen theater. These cameras can produce formats for the now standard TV formats (HD, FHD, UHD) but also for the "DCI" standards for movie screens that is a wider format, e.g.2K, 4K and greater.*

The Sony Alpha a7S II mirrorless interchangeable lens camera also offers 4K video as do several of its new mid-range cameras. Sony's new RX10 IV not only has 4K video it also has a built in 24mm to 600mm fast AF lens.

Panasonic, one arm of Matsushita, along with JVC, has also long been stalwarts in the professional broadcast video world. As with Sony, that is a world they understand and in which they perform well. The addition of the Lumix brand for still cameras has brought them, again, head to head with Sony in virtually all of their product lines. Like Sony they are heavily invested in the world of video vis-à-vis its functionality as added value and functionality to their still cameras.

Canon, best known for its still cameras, had also made "prosumer" and semi-pro video cameras (and before that, 16mm motion picture cameras) for a long time with an added bonus – they allowed the photographer to use any of Canon's normal "EF" mount lenses.

But it was Canon that changed the whole paradigm for digital filmmakers. Their 5D MkII was the first DSLR to add serious video functionality to a DSLR and, seeing the incredible response, they have continued to build on that ability putting video functionality into even their lower line of "Rebel" ("T" series) camera bodies. The 5D Mk IV produces very high-quality video.

This has spawned a new generation of independent filmmakers and a whole new

industry of makers of rail mounted "rigging" equipment to add serious filmmaking capability (rigging cages, follow focus, matte boxes, audio attachments, etc.) to DSLR and Mirrorless cameras.[30]

Additionally Canon has upped their professional level video line with the "C" series that looks like an unholy mating of a DSLR and an Armadillo, but that offers Digital Cinema quality in a small footprint package very popular with independent filmmakers due to their comparative low price and their use of other Canon Lenses.

Following the demand, Canon also brought out their own line of "Cine[31]" lenses which represents a major commitment to the digital cinema world. That functionality has influenced several of the major Digital Cinema quality camera makers such a Black Magic Design and RED to offer camera

[30] *As DSLRs and Mirrorless cameras start serving the same demographic a new combined label is needed to refer to them generically. Several have come and gone but the most common one I am hearing now is "IL" (Interchangeable lens) camera to refer to cameras roughly the size of 35mm film cameras using interchangeable lenses but which may have different viewing systems such a single lens reflex using a mirror and prism, rangefinders with separate optical viewing/focusing systems, or electronic viewfinders*

[31] *Cine lenses differ from normal still camera lenses in several key ways. They generally have less edge distortion, use "T" stops not "F" stops for greater exposure accuracy, have focus and aperture rings with no click points and are already geared for "follow-focus" attachments. As importantly, the Cine "zoom" lenses are generally "parfocal" designs which means they hold focus through the entire zoom range unlike the standard "varifocal" still zoom that must be refocused at each zoom setting. Plus, within a brand series, cine lenses generally have the same filter size.*

bodies with optional 'EF' lens mounts to take Canon still and cine lenses.

Several companies are now also making adapters to allow Canon EF lenses to be used on professional grade camera bodies with existing "PL" mounts " ("Positive Lock" system developed by Arriflex) which are the common mounts for high end Panavision and Arriflex cameras.

Nikon as well, has upped the ante with the new D850 DSLR which is offering 4K video capture and a high pixel count. Except for audio, it is a very effective video camera.

Sigma, an independent lens manufacturer began a few years back to re-establish their reputation after a period of somewhat questionable quality control. They first created a series of very high quality and highly respected still lenses and then, seeing where the world was going, brought out their own series of matching cine lenses.

Samyang, another independent lens manufacturer (in Korea) that fields several qualities of lenses under various brand names, some of which were almost an industry joke and relegated to amateur consumers on a very tight budget, also recently upped their quality game and then brought out a line of well-reviewed cine lenses under their **"Rockinon"** sub-brand... and then seriously upped even that ante with a new series (called **"Xeen"**) of very high-quality cine lenses.

Zeiss, Angenieux, and **Schneider** are very high-end lens makers that traditionally made cine

lenses in the standard "PL" mounts for film-based motion picture cameras and then digital cinema cameras. But they too are seeing a future in supplying lenses for the growing legion of still-to-video shooters and making many of their lenses now available with Canon's EF mount.

Although I did not survey them, **Fujifilm** has also now brought out a line of small digital still cameras with video capabilities.

Metabones, a Canadian manufacturer of lens adapters, is seeing a major uptick with their speed enhancing adapters to allow DSLRs and Mirrorless cameras to open apertures to better capture a cinematic-look shallow depth of field with slower still camera lenses.

It would be difficult to miss where all of these manufacturers see the photo world going based on their expenditures in equipment development and manufacturing.

SURVEY/INTERVIEW CONCLUSIONS

Conclusion number one is clear: the world of professional photography is changing drastically and rapidly. But if that was not already an accepted reality there would be no motivation for this document or exercise. The real question is HOW is it changing and where does that lead us as photo educators?

Based on the feedback from the questions and discussions above, while there is some confusion over the future of professional photography and some of the more

esoteric influences in play are real but may be years in the future before they become reasonably available and require new approaches in photo education, in some other areas the near future is crystal clear... it has already started and it embraces video.[32]

It also points to a near future where a nearly self-sufficient technology appears to handle basic camera/photo technical issues quite competently. That means that the issues of concept, aesthetics, and visual artistry, will take on new levels of importance to maintain competitiveness.

In fact, with technology becoming nearly autonomous, photographers may be closer to returning to pure artists than ever before and applying that artistic capability to the world of commercial image making in all new ways. For all of the disruption, this could become a really exciting time to be in this discipline for those willing to put in the time and effort to become and remains competitive.

We are, in some very real ways, playing out a photo-world version of the famous scientific thought experiment/analogy often referred to as (Erwin) "Schrö dinger's cat."[33] We know some of the major

[32] In 2012 F-Stoppers had headshot guru Peter Hurley compare photo prints he shot with his beloved Hasselblad digital and with a 5K digital Cinema Camera (RED). He declared he could not tell the difference. That was 2012!

[33] This must be one of the most misunderstood scientific analogies of all time. The then current (1935) understanding of quantum mechanics seemed to indicate than an object in a physical system actually existed in all of its possible configurations (a state of super position) until observed which forced a single state to be realized. The "cat" story was actually his way, via a "thought experiment" of saying that was impossible. The cat in the box with poison to be released randomly was not and could not be BOTH alive and dead at the same time, but was one or the other and opening the box

influences and possible outcomes, but precisely how they will play out will not be known for sure until we actually open the box, that is, until we can turn the calendar to the page marked "future."

But that does not relieve us from a need for preparations. We may not know the precise state or configuration of the "camera" we will have in 10 years, but we can be pretty sure it will produce high quality video and perhaps even be able to set itself for both stills and video to replicate the look of high quality iconic images.

Some seem to fear that will make formal photo education pointless and a relic of the past. I disagree; I think it will merely change the way in which photo educators teach and the material they will need to present.

To me, rather than being a death knell to photo education, the conclusions point the way to some changes in photo education we will need to address in our professional photo programs that can be exciting and filled with even more artistic and creative options than we have now. But we must do so quickly.

We are already behind the curve in some ways. We need to stop that erosion of relevance and make sure the lag between real world practices and education's teaching materials and practices does not expand. And that is what we'll be addressing next.

simply revealed in which state it actually was at that moment. It turns out that in the world of quantum physics, it might indeed be both.

Part Three: CONCLUSIONS & FINAL QUESTIONS

First, before I present my conclusions, here is a cautionary tale in the form of an old poem by Sam Walter Foss (1858-1911). It is over 100 years old but is as applicable today in 2017 as it was when written, and is as applicable in academia as it was in civil engineering.

It is at once humorous and deadly serious and the mentalities it describes are still quite alive and well and costs us as much in academia as it costs in the general public and business. Behind the humor is a deadly truth that we in photo education need to grasp.

THE CALF-PATH

One day, through the primeval wood,
A calf walked home, as good calves should;
But made a trail all bent askew,
A crooked trail, as all calves do.

Since then three hundred years have fled,
And, I infer, the calf is dead.
But still he left behind his trail,
And thereby hangs my moral tale.

The trail was taken up next day
By a lone dog that passed that way;
And then a wise bellwether sheep
Pursued the trail o'er vale and steep,
And drew the flock behind him, too,
As good bellwethers always do.

And from that day, o'er hill and glade,
Through those old woods a path was made,
And many men wound in and out,
And dodged and turned and bent about,
And uttered words of righteous wrath
Because 'twas such a crooked path;
But still they followed — do not laugh —
The first migrations of that calf,
And through this winding wood-way stalked
Because he wobbled when he walked.

This forest path became a lane,
That bent, and turned, and turned again.
This crooked lane became a road,
Where many a poor horse with his load
Toiled on beneath the burning sun,
And traveled some three miles in one.
And thus a century and a half
They trod the footsteps of that calf.

The years passed on in swiftness fleet.
The road became a village street,
And this, before men were aware,
A city's crowded thoroughfare,
And soon the central street was this
Of a renowned metropolis;
And men two centuries and a half
Trod in the footsteps of that calf.

Each day a hundred thousand rout
Followed that zigzag calf about,

And o'er his crooked journey went
The traffic of a continent.
A hundred thousand men were led
By one calf near three centuries dead.
They follow still his crooked way,
And lose one hundred years a day,
For thus such reverence is lent
To well-established precedent.

A moral lesson this might teach
Were I ordained and called to preach;
For men are prone to go it blind
Along the calf-paths of the mind,
And work away from sun to sun
To do what other men have done.
They follow in the beaten track,
And out and in, and forth and back,
And still their devious course pursue,
To keep the path that others do.

They keep the path a sacred groove,
Along which all their lives they move;
But how the wise old wood-gods laugh,
Ah, many things this tale might teach —
But I am not ordained to preach.

SPECIALISTS & GENERALISTS: A CONFLICT OF VISIONS

When I launched into this research I had very different expectations as to what would be the major influences on the world of commercial photography and therefore on the world of serious photo-education. I expected immersive photography in the form of AR and VR (Augmented Reality and Virtual Reality) to be the next

hot trends. Clearly that was not what others were expecting or for which they are planning.

But even so, I remain convinced as to the applicability of Complexity Theory[34] to our inquiry here. Our world, and not just the parts of it swirling around the heads of photographers, is so increasingly complex that it is increasingly difficult, and often impossible, for an individual to know all there is to be known about their own discipline. Sometimes one cannot even know all there is to be known about some area of specialization or even sub-specialization. We no longer seek to just "discover" or reveal information, we are now *creating* it.

And with that change has come a great danger. The only way for humans to deal with that vast collection of data is to segment it into workable chunks. But in doing so we have created little specialty-based fiefdoms that are so busy with their own growing knowledge-bases, they are losing sight of the bigger picture. And that modularization is creating a much larger danger.

In the late 1970s I was contracted to create training videos and instructional content for a Fortune 100 company headquartered in Denver. They came into being as the result of a series of mergers and buyouts and now had a huge minerals-based company that did

[34] *Complexity Theory is a mathematical and computational view that there is a hidden order to the behavior and evolution of complex systems and networks of systems from national economies, to organizations, ecosystems, on down to even a manufacturer's production line. All of the "networks" act as a single system made of many interacting components. Complexity theory attempts to explain how even millions of independent actors can unintentionally demonstrate patterned behavior and properties that, while present in the overall system, are not present in any individual component of that system. Read more: http://www.referenceforbusiness.com/management/Bun-Comp/Complexity-Theory.html#ixzz4xNnbEmuV*

everything from exploration and mining through end-user sales and distribution.

But there was a problem: the software programs from the acquired companies did not talk to one another so an entire section of data entry personnel was needed to manually correlate data from one entity and enter it into the database of another so it could then be combined, queried, and analyzed. It was time consuming and prone to error.

The company's solution was the employment of a famous huge data service firm that was charged with the creation of an enterprise application that would do it all and handle the needs as disparate as exploration, mining and transportation, sales and accounting, etc. and then be able to combine and correlate data to aid in business-wide analyses and planning.

It was a brilliant plan and they had just the right tool. The company owned IBM's largest non-"super" computer, at that time, an IBM 3090 mainframe. That computer was a delight to use; astonishingly fast sorting through mountains of data. It made my home PC (a new "fast" 386 machine) seem like an abacus with sticky beads.

The creation team members were quickly divided into areas of company activity and off they went to create computer magic. Everything was working wonderfully, each module was a gem, a ideal model for data manipulation efficiency.

Until, that is, they started uploading and compiling the modules on the mainframe.

To everyone's astonishment and anguish that beautiful, powerful machine now crashed on a daily basis and no one could figure out why. The problem was when a mainframe crashes and locks up, rebooting it is not a simple or fast as rebooting a PC and lots of productive time was being lost while the entire company, dependent on the computer, sat and waited.

The problem with the new program was elusive. The new code was perfect; the modules all, in a vacuum, did exactly what they were supposed to do. Each specialized area was flawless and efficient. But together they crashed a huge computer that was capable of far more throughput than was being asked of it.

It turned out, however, that the problem was devilishly simple. To function together all of the modules were written in the same computer language. But that language required, at the start of each module, a specified allocation request of computer resources from specific core addresses. And this army of programmers, each doing their own thing perfectly, never talked to each other to compare notes or methodology and they were ALL asking for the same resource address from the computer.

In that army of specialists doing perfect work, there were no generalists to note that each part was great... but when combined, they would blow up. Their team structure forgot, as has much of the modern business world, as well as the educational world, that there is an important difference between managers and leaders. We confuse "Tactics" with "strategy."

Managers are properly specialists; leaders are properly generalists. Managers deal with tactics; leaders deal with strategy. If, for example, a company is given the task of carving a road through the wilderness from one village to another, the managers' jobs are to keep fuel in the machinery, see that saws are sharpened, workers are fed and transported, etc. But the true leader's job is to periodically climb to the highest view point, look around, and say, "Wrong direction!"

An even greater level of complexity is now assailing not just our photo-educational needs, its own unique set of complex systems is assailing the educational *system* itself, adopted solutions to which are now coincidentally assailing our program as a result. The combination is creating a perfect storm forming an existential threat to the photo program.

Andrew McAfee and Erik Brynuolfssonrik, co-authors of "Machine, Platform, Crowd" write that we are in the "second machine age," a completely revolutionary period culturally and technologically where machines can do *mental* tasks in the same way machines did *physical* tasks during the industrial revolution (or in their words, the *first* machine age). Machines now not only can handle greater data loads than humans, they have error rates less than humans when it comes to manipulating huge and complex data sets.

What is interesting to note is that humans learning *alongside* and sometimes in competition with machines are themselves improving in their skills. For example, the Korean Go master, Lee Sedol, who lost a Go tournament to the computer named "AlphaGo" had previously been able to beat a bit over 75% of his human

147

competition in a game with, according to some, "...more possible moves than there are stars in the skies."

But after his marathon matches with the computer something unexpected happened: the Korean Go master, even though he lost to the machine, now was beating over 90% of his human competition. Similarly, when the same computer, AlphaGo, then played the Chinese world Go master (and won the tournament), observers said that both computer and human played nearly perfect moves and that the human played his best games ever against the machine.

To me this only reinforced a common observation among participants in skill-based endeavors: to get better at the activity, surround yourself with and compete with those who are *already* better than you are. Competing with those of less ability may be good for the ego but it is fatal for growth.

To me, from a technical achievement standpoint, it was even more significant when a computer won a "Texas Hold 'Em" poker tournament in Las Vegas. It is intellectually understandable that a computer can fill a huge database with lots of prescribed moves for specific situations completely constrained by rules, whether in chess or the more complex world of Go. But the variables of individual competitors, their styles of play, the concepts of bluffing, the randomness of cards being dealt, all happening at once in a poker game is something else. There are far fewer "rules" but a vast increase in unknowable variables. Still, the computer, "Libratus," won the 20-day, 150,000 hand tournament.

Yet computers have thus far failed to have the "native intuition[35]" that creates literature and art with human responsive emotional content. Those two factors, technical skill and emotional response are directly linked to our professional photography's future world and how we need to adapt, as educators, to meet it.

Computers stuffed into a small camera body may not yet be able to do what a super computer can do. But the operative word is, "yet." The new I-Phone is a more powerful computer than the room-filling ones like Univac and Eniac or even the ones that launched us into space... things are changing fast.

Carter Phipps in his book "Evolutionaries" makes the point that in the world of nature, generalists (think mice) that can eat almost anything are better able to survive changes in ecosystems than specialists (think Koalas) whose diet is limited to a single plant species. This concept has profound implications for our increasingly specialized society and for our discipline in particular. He writes further,

> "We've become a society that's data rich and meaning poor. A rise in specialists in all areas— science, math, history, psychology—has left us with tremendous content, but how valuable is that knowledge without context?"

[35] *This is illustrated by the computer's incredible ability to nearly instantly translate the words between various languages, to print out definitions, and yet have no true internal understanding of the meanings. They can quantify the definitions, the denotations... but not the connotations. A computer can recognize, differentiate, and label drawings of a strawberry and a puppy but cannot taste the berry or adore the puppy. It is also important to note that the computer that mastered the incredibly complex game of Go, cannot play the far more simple game of checkers...)*

As technology has expanded the photographer's creative options and made entry into the field easier, the growing population of would-be photographers has inadvertently created an environment of constraining specialization. There was SO much to know, so much that could be done that no one could do it all and so we began seriously specializing in various genres. And that inevitably and predictably led to specialization in the use of tools and processes. It became incredibly and artificially restrictive.

When, a few years ago, an agency here in San Diego contacted me about some architectural exteriors work, I selected the work for my portfolio to show mostly exteriors (as the job implied) but also added some interiors to indicate I could also do that. The A.D. (Art Director) looked at the exteriors, liked them, but when he got to the first interior shot his whole mood changed and he asked me why I would waste his time with those since that is not what he asked for. He informed me that if he wanted interiors he would have contacted another photographer... even after he declared that he liked mine.

A local acquaintance of mine who did both wedding and product work even had to create two different companies and attendant web sites and promotional materials since clients from one side of that world would be put off by thinking he "diluted" his expertise with that different side. It even reached a bizarre point where a studio photographer adept with and known for their work with a large format view camera was not the one called for a job requiring location shooting even though that

photographer might be equipped and able to do the job perfectly.

But the technology-driven world coming at us now is going to require a modification of that attitude. In fact, it already is starting down that road as is indicated by the increasing numbers of commercial still shooters now being asked to also shoot video.

Fascinatingly, the request is to shoot video of the *same thing* they were shooting in stills. Client's minds have not grasped that it is, for a talented photographer, far easier to shoot various and different *types* of things than it is to easily make the mental switch from capturing stills to shooting motion.

Shooting stills for a marketing *brochure* is a very different thing than shooting a marketing *video*. And this does not even address that the "Storytelling" aspect is operating on a whole new level.

The professional photographer in the very near future – meaning last week – needs to be a "technical" generalist in the sense of being able to embrace and master virtually all forms of optically acquired images, both still and motion. We, as their teachers, need to be able to present them with the range of materials that will make that possible.

Yet the commercial world forces a sort of pseudo specialization of styles and narrowly defined subject matter (i.e. portraiture, fashion, advertising, etc. then sub-specialization such as editorial portraiture, PR headshots, formal portraiture, bridal portraiture, etc.) while within those specialized visual subjects a generalization of technical expertise is being expected

and demanded. This perfectly reflects the conflict Phipps notes when he writes, additionally,

> We've become so focused on specialization, but just as there are truths that can only be found as a specialist, there are truths that can only be revealed by a generalist who can weave these ideas in the broader fabric of understanding."

I think here in academia we are facing a perfect analog to that situation. I would suggest that the administrative mandates now impacting our program are flowing from the minds of specialists who may well be wonderful and brilliant within the context of their specialties and academic subjects, but are inadequate and dangerous to some parts of the more general world of educational programs including, specifically, vocational programs such as ours.

It is clear that the photography program must evolve and change to meet this new reality if it is to retain its relevancy. But to survive it also needs the support and help of the school, college, and district, and perhaps State itself, in order to make those changes. So the first question has to revolve around the perceived value of our program when the economy is forcing all programs to be "triaged" and fight for survival.

So of what value does a program like ours have? For the community, for the region, for the state? And what kind of "value" are we talking about: purely economic or including social/cultural values as well?

THE QUESTION OF PROGRAM VALUE

If a program is to be embraced by any institute of higher learning, especially in economically tight times, it needs to demonstrate value on many fronts. The work of the newly graduated students should, for example, elevate culture wide productivity, knowledge, and values. Few processes can do that as well as the visual arts; and ever more so when that culture appears to be moving into a post literary mode relying more and more on imagery for its informational input.

During economic boom times with full treasuries, greater employment, and greater student enrollments, the system could afford the luxuries of adding more and more non-core but warmer and fuzzier, politically correct "identity" studies and courses. They could even sell themselves that such additions made them better partners in advancing a civilized society.

Perhaps there is some truth in that. But with an economy turned down or even just flat, with money tight and good jobs scarce, many tougher core courses are ill attended and dropped resulting in faculty competition for FTEF.

A necessary impending course triage may force a re-evaluation of what role various courses play in preparing students to be *contributing* partners in a new world. Being nice and sensitive is surely a good thing, but it does not put food on the table or taxes into the State coffers. By arbitrarily limiting class offerings and units for a student, the college has created an educational zero-sum game of finite numbers. Concentrating on sensitivity training, when it diminishes units available

for core training, will, in the new world barreling down at us, simply create a larger proportion of those unemployed and unemployable people we mentioned earlier.

Unfortunately, the results are already showing up in the students. Identity and group sensitivity courses added to High School curricula have not been dropped during lean times, but many arts-based classes have been. At the same time many remaining core classes have to be artificially modified to avoid seeming "insensitive." Even math is now viewed as inherently discriminatory.[36]

Regardless of what is happening outside our hallowed halls, academic "culture" no longer strives to be a melting pot but rather a tossed salad. Were we all in a collective cooking class we'd be told that Johnny's (or Jane's) concoction of chicken ripple ice cream with ochra sauce was something we should all learn to love so that the maker will not feel bad if it were rejected.

Perhaps in the insolated environments in which academics collect that is how it is, and they have, based on that experience, extrapolated that into what they believe the rest of the world is like. But in the work environment of the professional photographer, that most assuredly is *not* how it is.

I do not see how it possibly gets more insensitive than cheating a student's future to function in the real world. It is little wonder that out in the real world that failure of the educational system is almost a cliché.

[36] *https://www.campusreform.org/?ID=9627*

Students cannot count change as a retail clerk, in fact without a calculator they cannot do simple math. They have no clue how the country functions or for that matter where much of the country is located on a map. They are, instead, infused with the pointless inanity of trying to impose modern sensibilities on centuries old people and then find them wanting, despite prodigious accomplishments, when they don't measure up on the proper sensitivity scale.

The resulting skewed views of historical events and people eliminates real understanding and with it, a real foundation and appreciation for growth and progress. The situation is made even worse with the growing unwillingness to even hear other views and opinions that do not march in lockstep with the accepted "correct" view or sing in unison with the academic choir. At a time when critical thinking is becoming ever more important it is as if academia is devoted to killing that ability.

Students are less and less able to read serious literature much less complex scientific and philosophical texts. Already cursive script is no longer being taught and I've had students unable to read something I had written on the white board in cursive. I had used cursive because it is, for me, faster than printing. And handwriting in print mode is so much slower, it is generally avoided in favor of typing. And that has an impact on the intellectual quality of what is being produced.

The speed at which even a fair typist can write is so much faster than they can hand write in print, that the normal deliberative process of transferring carefully crafted thought being worked out and massaged as it is

written to paper via a pen is being lost in favor of a nearly "stream of consciousness" flow of what is becoming pages of unintelligible gibberish.

Added to that is, based on papers turned in to teachers, the use of spell or syntax checkers is simply too slow or too inconvenient to use. The ability to read and understand, much less compose a complex, compound sentences I learned in High School has eroded as the old school technique of diagramming sentences has disappeared.

Authors of rich, vibrant prose like Kipling, Stevenson, even Hemmingway, would have their papers summarily rejected as not containing the proper "active" voice and following Bloom's Taxonomy[37] which has, in practice, devolved into the imposition of simplistic, "See Spot run" level of subject-verb-object processes.

It is little wonder then that imagery is becoming the information transmitter of the future. And that adds importance and value to programs like ours as little else does.

Imagery contains connotation and implication just as do written words. As noted early in the discussion, color, arrangement, tones, balance, all carry subtext information and convey emotional responses and

[37] *Bloom's Taxonomy was originally published in 1956 by a team of cognitive psychologists at the University of Chicago. It is named after the committee's chairman, Benjamin Bloom (1913–1999).. Their initial intention was to help academics avoid duplicative or redundant efforts in developing different tests to measure the same educational objectives.by creating a classification system used to define and distinguish different levels of human cognition—i.e., thinking, learning, and understanding.*

intellectual stimulations whether the image creator intends it or not.

A famous story of this precise problem comes from Hollywood when the English Actor Peter Ustinov, a linguist who fluently spoke multiple languages was asked, in a desert epic, to talk in character to the native Tuareg tribesmen serving as extras and "atmosphere" in Arabic. But, it turns out, he did not speak Arabic.

However, after listening to the tribesmen talk amongst themselves, Ustinov believed he could mimic the sounds sufficiently that an American audience would never know the difference. So he launched enthusiastically into his 'monologue' making, to him, pure phonetic nonsense sounds.

Suddenly the tribesmen's attitudes all changed. In a heartbeat cheers turned to scowls; the mood turned dark and menacing and they all went for their jambiya knives. They started moving toward Ustinov and were on the verge of attacking him because, it later turns out, he had managed, in perfect Arabic, to insult all of their mothers referring to them in terms questioning their parentage and with labels suggesting their employment in certain ancient professions simply not to be countenanced when speaking about one's mother.

What was utter phonetic gibberish to Ustinov was delivered so perfectly that it took a great deal of convincing for the tribesmen to accept that he did not speak or understand their language, did not intend any insult to them or their mothers, and was, in fact, only mimicking sounds and patterns he had picked up from hearing them speak to each other.

Image makers, important as they are in this culture, risk this same sort of unintentional misstatement without proper training. With that training, however, our students can elevate and enrich the world around them, they can foster behavior that is positive for their clients, and they can both reveal and illustrate their world in accurate and meaningful ways.

Teaching them how to do that is our job and our duty.

Photographers are a sort of visual philosopher, an ontologist to be specific. We often examine the "state of being" around us and present our conclusions in visual terms to our audience.

We show them wonders they've never before seen, transfer emotional responses and generate critical and reflective thinking with our images.

But we can accomplish that only when we speak the language and understand the audience. This conflict noted above between generalists and specialists has an impact on both the photographers' professional and personal worlds. Resolving it has a major impact on our success. Providing the tools for that resolution is the often hard but critically important job of education.

We also, as an "applied" program under the definitions of the California Education System, are one of the very few programs that can and does graduate its students directly into the work force to become part of the economically productive tax base.

For a State in a condition of technical bankruptcy[38] one would think that a program designed to accelerate entree into the tax base would be seen as valuable. Based on mandates for how we run our classes, usually blamed on the State authorities, one would apparently be quite wrong in such thinking.

And that leads us to the point of all this: what are we to do with our program and courses especially considering our anticipated changed and changing "New" world.

Some futurists believe we are headed toward a completely distributed and autonomous world. For our discipline that means that, in their view, we are headed toward a completely decentralized style of education with self-study as the most common methodology.

That leaves little or no need for schools, and in the end, by that view, we will also distribute our work product or attract our individual buyers/customers/clients/collectors all on our own (via social media or the internet) and let the world take our work as it wishes.

This, as it applies to us, is the commercial arts version of Marx's economic vision of society in which, in practice, every time it was applied it generally lowered the overall quality of work, leveled the playing field for all by chopping from the top, and induced the fairness of mediocrity. And with no noticeable exceptions, the audience comes to accept it and the push toward old world and old school excellence is lost... maybe forever.

[38] *An economic condition where liabilities exceed real or reasonably to be expected revenues.*

I disagree, both with the goal and the prophesy. The problem with that perspective, in my view, is that old wrench in the works, economic issues, i.e. money. Commercial photographers work in order to provide content to help their clients make more money. When the level of work evens out, the level of revenue evens out as well. That quickly becomes a problem.

We are humans, members of a species driven to be inquisitive, acquisitive, and territorial[39] and sooner or later at least one of those clients will want more than the competition or at the very least, wish to improve their own lot without regard or concern for what or how others are doing.

Eventually they will be tired of joining everyone else rush down to a lower common denominator and seek to rise above the muck. That desire to stretch, to expand beyond the norm, seems to be hard wired into our genes[40] and I believe that while it may be beaten down for a while it cannot be eliminated.

At least I hope not.

At some point I believe there will be clients that will remember basic marketing 101 and the concept of "Implied Value" and realize the way to break the chain of mediocrity is with marketing content so much better than their competition's that it 'blows the doors off' of the competitors and gains the new-found attention of consumers to that client's products or services.

[39] *Harris, Marvin, "Canibals and Kings;" Ardrey, Robert, "The Territorial Imperative"*
[40] *Lockland, Geroge T: "Grow or Die." Maslow, Abraham: "Hierarchy of (human) Needs"*

The content providers who have not succumbed to the generalized quality malaise and have instead used that time to learn their discipline inside out, who have become, in essence "Black Belt" photographers where you are required to learn different arts to advance, who will have learned stills, video, AR, VR, etc., understand web site and mobile app issues, will be the ones to rise to the top of their respective food chains.

Our job as educators, if we or our program are to have *any* value, is to prepare students for that moment. When my teaching partner, Dave Eichinger, and I were given the reins to the photo program in January 2005, we sat down and created a vision for it embodied in a mission statement of the utmost simplicity: to create and maintain the very best photo educational program... period.

That mission objective has not changed. But the arena in which it operates has changed continually and dramatically since we accepted that challenge. And now, based on all the material covered here, it is about to change dramatically again – and in the very near future.

And that leads me to the following chapter and its recommendations not just for our program but for any photo educational program that wishes to prepare their students to take a meaningful place in the world of professional photography.

So far we've been talking about the value of the photo program. That is, after all the target for this research paper and the very reason it was undertaken.

But a larger issue is looming in front of us and I can't move on to our specific program recommendations

without at least asking a critical question; not just about the photo program, but about education, broadly speaking, and our educational mission as a school.

If the growing number of historian pundits are correct, and sometime in the next 16 to 30 years we will be facing a world with well over 50% of the inhabitants around the globe being, in their words, "Useless" since there will be no employment for them of any kind regardless of re-education or retraining programs, what are we to do about it?

The "Normalcy Effect" says many of us will deny it and the closer to the point and time of impact, the more vehement will be our denials.

Others seem to accept that grim prophesy but throw their hands in the air whining the common loser's lament, "But there's nothing we can do about it!"

Still others believe that, yes, it will likely happen, but we'll magically have a wondrous new technology, as yet unannounced, standing by to save us and turn us into a "Star Trek" world utopia.

Some believe that those of the useless class will simply create some entrepreneurial enterprises such as happens now in ghettos with the drug culture. And others think we will end up returning to an agrarian culture and personal farms and in essence have a completely bifurcated culture.

All of those are possible futures for us but, setting wishful thinking and delusion aside, at this point there is no logical reason to expect one over the others to win out.

Growing up in farming and ranching country with no stores "down the block" or repair shops "around the corner," I grew up with the attitude and practice of a "contingency planner." Whether it was an issue of crop failure due to drought during the growing season or flooding during the harvesting season, livestock's wellbeing, or vehicle maintenance, one hoped and prayed for the best but always prepared for the worst.

In essence, we adopted the day-to-day civilian version of the Roman quote, "*Sic Vis Pacem, Para Bellum*" (If you want peace, prepare for war) into "If you want success, prepare for hardship."

If the worst-case scenario happened, then you were prepared for it and able to deal with it. If it did not, then you breathed a sigh of relief, congratulated yourself on escaping problems, and enjoyed the extra materials, supplies, and maybe even new skills you had gathered as part of your preparations. And amazingly, the more and better you prepared, the less often the worst seemed to happen.

So, my question is this: should not education systems generally, but, at least our own educational institutions, be doing all they can to prepare for that worst case and learning how to try to assure that our students and graduates have a better chance at being the 30-40% of people in the "Use*ful*" class than the remainder of wretches in the "Use*less*" class mollified with a survival level governmental handout and brain numbing virtual reality games?

I ask that because if we cannot, or *will* not, start identifying and then putting those plans into action,

163

then how do we intend to justify our existence if the worst happens?

It will have been WE in education who turn out to be the most useless class of all because we were the one group that could address the problems and failed to do so. We will, of course, blame governments and politicians (who will certainly have their own share of the blame) but the solution to a problem of runaway technology is not political; it is educational

And if the worst does *not* happen, then our preparations may actually see us once again being the poster child for excellence in education. I do not see how that is not an excellent goal.

Part Four: PHOTO PROGRAM RECOMMENDATIONS

For our program to remain relevant and valuable to our students, I believe we need to make the following modifications and accommodations (or something very similar) to both our program catalog and course curricula. However, let me be honest up front: I'm under no illusions that such changes would be easy; indeed, I'm under no expectations that the administration levels from the State to the district, would jump to support them.

With current attention focused on academic programs and transfers to help ailing 4-year universities, our vocational program is clearly an "outlier" program in both topic and needs. We have been asked, somewhat sarcastically, if we think we are special in some way when we've submitted some of our requests. The answer is yes, though I would prefer to use the less value laden term, 'unique' instead of 'special'. We are unique because we operate in a world that is completely foreign to that of most academic subjects.

Most programs luxuriously plod along with little change in their fundamental underpinnings that would suggest radical departures in approach for them. But despite that, we remain, nevertheless, a discipline in the midst of a paradigm change occurring in the midst of a

previous paradigm change that is still evolving. Almost everything about the world our students will enter is in flux and is changing at the speed of the internet.

It is disorienting, wonderful, maddening, magical, dangerous, and yet filled with potentials that are limited, truly, only be imagination. It is a wonderful and exciting time to be involved with the discipline and art of photography. But it is not a very relaxing one.

Following are some of the changes or modifications or additions I think we need to be considering and trying to put into effect to prepare our students for this changing paradigm. Perhaps this document can also encourage a new look at the value of our program to all involved and that value may make consideration of these recommendations more palatable.

I understand that unique or not, we exist in the midst of a larger bureaucratic system with well set and traditional constraints. What we need and ask for is sometimes like trying to turn an oil tanker in a bath tub – the will is there but the space doesn't allow it. But we have no choice except to try even at the risk of splashing water on a clean floor.

CONCEPT, CREATIVITY, AND VISUALIZATION

As technology levels the technical playing field and removes the heretofore difficult technical obstacles to producing competent images, one thing remains to differentiate between individuals who are both artists and commercial professionals -- concept.

That puts an additional and generally unexpected burden on photo instructors. But it has always been a standard requirement among traditional fine arts teachers in art schools.

I went to the Kansas City Art Institute and then to art school at the University of Denver studying painting, printmaking, and sculpture. In virtually every lecture or demonstration, concepts of creativity, aesthetics, composition, etc. were woven tightly into the course work. It was a constant subtext. And "Concept" was seen as a major component.

Any good thing can, of course, be pushed too far. When I was an undergraduate at D.U. "Conceptual Art," also called "Conceptualism," was all the rage. It all but eliminated, for a mercifully short period, all interest in execution skills. That was a fine philosophical experiment for those instructors who already had the traditional skills and could now play intellectual games. But it crippled students by NOT teaching them those foundational skills and severely limited their future options.

But in our case, the technical innovations are rendering execution issues less and less an issue because they are being handled automatically "behind the scenes" so there will be less and less to be taught. That leaves primarily "concept" as the working photographer's competitive edge and the topic that will need a whole new level of attention in the photo-educational process.

Even if, for example, your camera can reproduce an image to match one of several iconic photos, all top quality, the photographer still must determine which is

167

best for their own vision and maybe if none of them are, what to do then. Without the vision – the concept – that decision is not possible.

It makes sense in terms of allotted topic time when you think about it. The various genres of traditional arts demand very little technical underpinning. We did not make our own paint, or brushes; we were not required to fabricate our own sculpture tools or engraving tools or weave our own canvas. A certain level of drawing skill was a "given" to some degree as demonstrated by the portfolio requirements for enrollment, so that meant that the instructors could concentrate on creativity and any aesthetics more or less specific to the medium we were working in at the time.

Even so, drawing is not a technical skill in the sense of camera controls; it is, at its core, simply eye-hand coordination developed with large amounts of dedicated, directed practice. The photographer's analog in a world where technical issues are being solved by the camera system, is not his or her hand... but his or her "eye."

Traditionally photography has always had a major technical foundation to be mastered before one could get to the issues of aesthetics. For those working to learn professional photography in my day, for example, we had to be able to make images with complicated view cameras that were in focus, distortion free, and well exposed before we could get overly immersed in the aesthetic part.

Consequently, traditional photo education in all but strictly "fine art" applications has generally favored first teaching the technical and then the aesthetic topics of

composition and creativity. Unfortunately, with a finite amount of time available in a community college, it was the aesthetic side of the topic list that too often received short shrift (in the modern sense.) Soon there will be not only plenty of time for it but a new level of importance and it will be a major sea change for many instructors.

That traditional process became so entrenched as a matter of habit that some photo instructors even dismissed the idea of teaching creativity at all, hiding behind the idea that it is something innate, that you are born with it or not, and not something that can be taught. But that is an idea and rationale that traditional artists, masters, and art students, have known to be false for centuries. We are ALL born with it. It is our creativity and capacity for imagination that makes us human.

Consequently, creativity is not even something limited to the arts and, in some ways, is an essential element in all progress on any front. Creativity is driven by a need to solve problems that the accepted paradigm cannot solve. Its fuel is emotion, but its ignition is a crisis of some sort. But that crisis in the form of a problem that the available tools or knowledge cannot solve, can be found not just in the arts, but in virtually any discipline from engineering to science.

Indeed, in all of the fields of human endeavor, a true consensus is anathema to progress, discovery, and growth. Almost every great scientific breakthrough has come from someone refusing to accept the current consensus of thought.

If structural engineers, for example, had not thought out of the box and learned to use steel "bones" as potential building skeletons we would still all be living in a 3 or 4 story brick and mortar world. Yielding to consensus would have us still living in an earth-centric universe made of crystal spheres, still dying from the black plague, still bleeding patients for everything from "hysteria" to "bad humors," still ramming knitting needles alongside the eye for frontal lobotomies, still believing in black magic and phrenology.

It was the brave and sometimes persecuted who realized those paradigms, regardless of common acceptance, were incapable of solving real problems and had the temerity to look deeper into uncharted and sometimes dismissed territory for answers. Consensus is and always has been a highly successful antidote for progress.

But progress is disruptive and highly uncomfortable so wrapping oneself in the warm and comforting blanket of consensus has enormous appeal. But we operate in a small space in the universe of endeavors and when around us progress is swirling and changing that larger universe, we ignore it or hide from it at our own long-term peril.

Traditional artists in all mediums, including music and literature, have always known that creativity is an inherent trait of humans. The problem for the newly industrialized world 100 to 150 years ago was that the needs of that expanding industrial workplace were more focused on workers and so the educational system evolved to provide the world's best corporate and industrial fodder.

And the plan was a roaring success. American workers created the industrial marvels of the world; it was American industrial might that, when called upon in a crisis, created almost overnight, the materiel needed to win two world wars. That success was, to a large degree due to the existing American educational system.

That accomplishment cannot and should not be downplayed. But based on the world's future as I've suggested here, the continuance of that policy can certainly be questioned. And it *must* be questioned in some specific areas such as the teaching of our discipline, professional photography.

Creativity, as a topic was frowned on in the corporate environment because it created, in the corporate, bureaucratic minds, "loose cannons" that could not easily be controlled or directed. Eschewing the word, however, independent contractors were usually brought in when the company realized they were falling behind the curve and needed someone to supply the corporate/industrial euphemism for creativity, i.e. "innovation."

The objective in art schools, since there it was understood creativity was hardwired into the human mental process but had been dulled down by traditional corporate-based education, was never to *create* it but to *re-awaken* it and bring it back to the fore. Some few students had survived general public education with their sense of creativity intact but most did not. So even if something seemed to drive them toward artistic pursuits, the art teachers knew they had to fully re-awaken that artistic drive, something Jacques Lipchitz, a sculptor, referred to as "a deep inner itch that has to be scratched."

But photography had other challenges to be addressed first: climbing the wall of technical skills needed to operate the equipment and handle the chemical processes. But as that technical obstacle course facing students in professional photo programs is eroded into a level playing field by the advancing technology, the only competitive edge remaining will be the photographer's creativity; their ability to conceptualize new and unique imagery to help sell the products and services of their clients.

And that means that a successful professional photo program must teach its students how to apply critical and reflective thinking to that subjective process. And *that* means a return to a major emphasis that is no longer focused primarily on the technical but focused primarily on the aesthetic. In many programs and courses, the technical versus aesthetic roles will need to be switched in terms of importance.

And that means the educators wishing to remain such, may need some serious remedial training themselves. They already have much of the photo-specific knowledge available and it would be incredibly wasteful to lose that resource. So schools, to maximize the knowledge base and resource value already in place will need to accept the need to support some retraining via classes or workshops.

MOTION CAPTURE

Just as I was writing this paper I received an email from a national company located in Solana Beach, CA, near San Diego, seeking a student intern who was capable of

producing marketing content as *both* a still and video producer. Because we've been prohibited from offering a video for still shooters course I've no one I can recommend. And that is extremely frustrating.

Over the past Christmas buying season, internet ads using video had an enormously greater success ratio of leading to a sale than still images. That success has not been lost on marketers and retailers. More couples want video of their weddings than ever before. All that demand is being answered by the manufacturers who are incorporating video of higher and higher quality into their DSLRs and Mirrorless camera bodies... and even cell phones.

At the same time, high end video and digital cinema cameras are incorporating the ability to pull a high quality still image from the video frames. In the old days a video frame made a still of such low quality it was usable only in desperation by newspapers or other outputs that did not demand high technical quality. Right now, however, they can rival DSLRs of a few years ago and soon will match virtually any output need for a still image.

Bottom line, these two approaches to image making, completely separate for so long, are now beginning to merge. And as our program will have to change to reflect the increasing dependence on creative and aesthetic qualities, it must also accommodate the merger of stills with motion in the commercial world.

This is really very simple. We either teach them those skills both separately and combined, or we cheat and fail them in their quest for success in the field.

LEGAL ISSUES

Because of the ubiquity of image-creating devices, issues of privacy and the trampling of personal rights joins the increasing ease of stealing the work of others on social media and the web as legal issues. This can be a mine field for the professional photographer where, under current law, they can not only face charges for privacy infringement as well as the appropriation of personal and property rights, they can lose money and their own property rights through badly managed protection of their own intellectual property creations. This really is becoming a murky quagmire of legal liabilities and we need to make our students ready to enter that minefield aware of it and how to protect themselves.

To do that, we need to offer a class on the legal issues for photographers. That course's curriculum has already been written and accepted by the board. But there is a text-book level "Catch-22."

There is no way to offer such a class without the instructor, either in lecture or in fielding situation-based questions, offering, by definition, "legal advice." It is, however, illegal for a non-attorney to give legal advice upon which others may rely. That would expose not just the instructor but also the college and district to liability. To keep us from running afoul of the law in that way, we need to have that class led by an adjunct instructor who is a *current* member of the California Bar.

I graduated Law School in 1973 but went right back into the commercial photo world and never practiced or

renewed my bar "ticket." I try to keep somewhat abreast of current intellectual law but it is getting so convoluted due to the internet's ease of distribution and image theft coupled with cell phones snapping away everywhere, that it really takes a full time attorney specializing in it. It is hard enough trying to keep abreast of developments in my own working field. But even if I were completely up-to-date and knew all the latest case laws and precedents in the intellectual property side of the law, it would be illegal for me to give legal advice.

But here is the catch. We've been told anyone hired to teach in the photo program needs to have credentials in photography. We need a waiver of this directive so we can bring in a current attorney familiar with intellectual property law, contract law, and tort law as it pertains to issues of privacy to teach or help teach this specific and unique subject.

CLASS SIZES

We are being told that the State wants classes to consist of 35 students. The reason is obvious and reasonable from an economic perspective in a state where higher education is heavily subsidized: that number of students means the student fees will add up to the point where education, which is expensive to provide, is less of a huge money pit for the state.

For traditional lecture-only classes that number is probably workable. But in combination lecture/lab courses in creative topic subjects, where students interact and engage with the instructor in hands-on scenarios and training on equipment, it simply is not

feasible in an environment that also does not accommodate TA's (Teaching Assistants).

Moreover, it is also a physical impossibility for us when our darkrooms have 24 enlargers and our digital labs have 25-27 computer stations. In a display of mathematical brilliance way above my pay grade, a VP told us to then "...just 'Average' that number."

I am a simple country boy and freely admit to a profound lack of mathematical skills myself. But I am totally at a loss trying to figure out how to *average* a number we cannot reach at a *maximum*. I'm only a professor; that special mathematical knowledge must be reserved for VPs and above; or perhaps it actually works in the world of "new math." But I was lost. When I asked about that apparent problem, we were told, simply, to "Work it out." That was followed by the suggestion that possibly we ought to start our own school.

That was not supremely helpful. Actually, it *was* helpful in a sense because, surprisingly and sadly, it revealed the system's underlying position in a way I had not realized before. And it meant we were in trouble.

Nevertheless, math challenged or not, we, the photo faculty, do have quite a few years of experience at this. It is clear from those years of experience that our optimum lecture/lab class size is no more than 12-18 but we can usually handle 20-25 without a huge loss of interaction.

But it turns out the "Averaging" suggestion was vaporware anyway. Based on a promise to let us "Average" enrollment numbers from online classes, we designed and implemented several online courses

despite our contention this was not the best way to teach creative subjects. I allowed 40 students each into back-to-back online classes with a cap of 30 purely to try to get some numbers high enough to "Average" out to save a lightly enrolled business class which is incredibly important for our students. It turned out to be a huge mistake on my part.

I could barely keep up with the class work and online interactions and we were then refused the averaging plan to save a critical business class – which was cancelled anyway. Now we are asked to *cap* online classes at 40. It is an insane number for online classes that are attempting to simulate creative lecture/lab classes. It might be completely workable for lecture-only classes, but that practical component of lab work and the creation and subsequent critique of assigned projects is proving to take 2 to 3 times the amount of time it took in a classroom environment and is simply overwhelming.

So let's put this issue back into perspective. Remember early on I discussed the problem that all that was going to let professional photographers be competitive is extraordinary artistic skill and talent? If that is correct, and if employment generally might be in jeopardy, then that stand-out, self-starting skill and attitude will be even more important. Forcing students into crowded face-to-face or online classes where the instructor cannot properly interface with them is openly counter-productive to that goal.

Whether in photography or any other disciplines, education is soon going to have a level of critical need it has never experienced before. We ALL have to prepare for it. Yes, education has a cost associated with it; but it

also has a value both to the student and to the State. The question is whether or not that value is sufficient for the State to allow some specific smaller classes and be willing to charge a little more while the student in those specific types of classes are willing to pay a little more to create viable, relevant educational experiences for its citizens.

I understand the arbitrary assumption of the mantle of "fairness" in wanting to apply the same standards and constraints to all disciplines and course. But to do so is simply real-world ignorance gone to seed and then watered and cultivated carefully. And it is openly hypocritical. At the same time we are told that we cannot be seen as "Special" we are told to recognize the special needs of some students. Wait a minute: there are special cases or there are not. The truth is this is an issue of economics hiding behind the shield of pretended fairness.

It's a clear, simple question and so is the answer, or rather it is once the *political* philosophy is taken out of the educational equation. Philosophical shields are wonderful because one can pick and chose the philosophy and the rationale for its application without regard to any real-world consequences. Good PR and self-congratulatory stories are incredibly satisfying, and it is easy to see why they are appealing.

However, if the students' needs are honestly placed first and viewed in terms of real -world dynamics, the actual bottom line is incredibly straight-forward: the state down to the district authorities need to decide if fielding successful tax-paying citizens has value. Yes or no?

But regardless of the answer to that student cost issue by the State, the reality of our situation is remains clear. Under today's administrative demands, we cannot provide the required level of attention and interaction needed to prepare students for today's world, much less the one headed our way. Moreover, if we cannot better limit our classes and, for advanced classes, be allowed to run some relatively small ones so students can complete the program and successfully enter the work force, then the promise of our program is a myth... and so is that of the college.

LAB FEES

The actions proposed in this to help our program have a significant budgetary impact, there is no escaping that. But in fact, the truth is that already our "Master Plan" budget will not fully support the program needs and we rely heavily on CTEA/Perkins grants for vocational programs to fill in some of the missing dollars. We could also defray some of our major lab and studio and check-out expenses if we could charge modest, reasonable lab fees.

We were told, however, that we could not charge lab fees because the State said so. Not to put too fine a point on it, but that is a lie.

To back up my bold accusation here are two facts. When this issue was first raised we did a search of other photo programs in the state and found that lab fees in photo programs were common in other districts. That would not be possible if they were illegal based on state regulations. The nail in the coffin of that lie however is

the State's own Educational Code's terms which clearly spell out the requirements for charging lab fees... a bit strange if they were actually forbidden.

Unfortunately, those regulations about what can and cannot be charged to students are, as they pertain to photo programs, nonsensical in their local interpretations and have been construed as if they were completely prohibitive. Indeed, those regulations are applied to photography on what can only be seen as some attorney's singular body of ignorance about the actual photographic process.

The basic rules are that students can only be charged for things they take with them when they leave or that they use up and deplete. That makes sense. But its application for us does not.

To someone not aware of the process it may appear that the student left with or used up nothing of ours when they developed film or made prints. But that is not accurate. They leave with a product that is the result of chemical reactions and chemical depletions from materials we supply and without which they could not produce the final results. If nothing was used we would never have to replace them... duh. But that replacement is constant and expensive.

It is more obvious for digital printing where you can see the ink on the paper. But a difference in chemical interaction does not mean that the students take nothing of value from the darkroom. For those that don't believe that, let them set up their own darkroom and see the value involved.

A similar situation happens in the studios. Learning the use of a photo studio is essential for anyone wanting to be a professional commercial photographer. But the studio is not simply a large empty space in which to work. Students starting out cannot afford their own studio spaces, but more importantly they cannot afford the supplies and equipment, such as lighting instruments, entailed in studio use.

We have the best equipped studios this side of New York City. If one needs to get down to the quantum levels, the photons that create the images in their cameras come from our lights and do not return. Those lights are expensive and the light elements, bulbs and flash tubes, have finite life spans and are being replaced on a regular basis.

The backdrops are constantly being walked on and made useless and so need replacing. Students aren't just using them, they are destroying them. We have minimal repair or replacement budgets. When a student breaks something the district is "self-insured" which effectively means it has no insurance and we are not able to fix or replace the damaged item easily.

Beyond recognizing that the assertion that the student does not leave with anything they did not bring into the studio is absurd on the face of it, it has to be recognized that to teach students to be professional in an "applied" program, those studio-related costs are unavoidable.

The simplest and cleanest way to defray those costs is to do what several other community colleges in the state do: charge a small and reasonable lab fee for their use. We have several times surveyed students on the topic

and found that many were surprised that there already wasn't a lab fee schedule in place. We've had incoming students from other community colleges ask what the lab fees will be, expecting there will be some.

We appear to be the only hold out not charging a small fee to cover the costs of using our labs and studios and we need to change this policy because we cannot afford not to and yet continue to provide the level of service we have been doing in the past.

Perhaps the prohibition blamed on the State was generated at a lower level; perhaps it even was generated for a benign reason to keep costs lowered for students. But students in California already pay some of the lowest educational costs and fees in the country BY FAR. Only Wyoming is cheaper but not by much. Most States are at or near the $100.00 level per credit.

In normal "fat" times it could be argued California's state subsidized largesse is a good thing. But these are not normal fat times and the future, at least in the short term, looks like it is going to be even more grim economically.

Lab operation costs are a statistically significant part of the costs of running our program. When we surveyed students not one of them objected to a reasonable fee to use what is clearly the best darkroom facilities in the State. By recouping some of those lab costs we can defray some of the costs of smaller class sizes and create a solution where everyone benefits: the students, the instructors, and the schools. If the district has a strong belief that it is not fair to charge some of the poorer

students any fees, then they should still allow the fee and cover it for those identified students.

However, solving this may require an application of some of that innovative initiative talked about above.

TOTAL DURATION OF PROGRAM

Given the new world for which we are trying to prepare students, I see three models as workable starting points: The first is to maintain the current model but allow us more time. A few years ago, when it initially came up, we submitted a proposal for the Photo program to be one of the pilot 4-year programs for community colleges. That is still a good solution for us in terms of needed time. We already have in place the facilities, the faculty, most of the program, and have no direct competition anywhere south of Los Angeles.

A second middle of the road fallback position using the current model of individually titled classes, is to give us at least three or even four years to provide the tools that will be need in the early parts of their photo careers but still only offer the AA degree. This requires no changes to anything except that students can now take more of the important courses. But it only works if tied to the issue of class sizes.

The third model is a complete reversal into an immersive world of photography and follows more closely the Oxford/Cambridge model. The primary program is simply broken down into, for example, Photo 1, Photo 2, etc. with a student counselor from the program guiding the student to ancillary courses they

recommend based on the student's track. This too *should* be a three-four year program given the increase in technology-based subject matter.

Given the new demands on the photographer entering the professional business world, two years – four semesters -- which includes the general ED materials, simply is not enough time. We need to have the college/district or whatever entity has a voice in this decision understand that to do as we are mandated, i.e. prepare our students to leave school and be able to work in the industry, community colleges need, in some disciplines, to allow them more than four semesters of work.

And, as an aside, the program should also be able to also accommodate working professionals who would like to come and take a class to hone certain skills. Not only is this a valuable service to the community, it also is a great motivator for other students when a fellow student produces top notch work. They expect the "masters" we show or even the instructors to produce work to a high level, but when another student does it there is no escaping the implication that they, fellow students, can do it too.

It is easy to understand how adding such students in a subsidized educational world results in a negative budgetary impact. But that could be solved with a sliding scale of fees similar to the increase in fees for out-of-state students.

CERTIFICATIONS

As already noted, clients are utterly ambivalent about degrees and certificates for photographers, caring only for the quality of work demonstrated in their portfolios or reels. However, the students themselves, like all humans, are motivated by legitimately earned kudos and acknowledgements.

The good self-starting students – the ones who will have a chance at success – are sometimes insulted or offended by phony "participation" trophies. But on the other hand, acknowledgements they've earned for and by their hard and skilled work are often highly motivational. When we have done something good and know it, it is always inspirational to receive some acknowledgement of it.

We have already started to add certificates of achievement to our program as motivational elements and will continue doing so.

COURSE FAMILIES

This concept – course families -- was dropped on us, frankly, in a way almost designed to be confusing and misleading. We believed, based on how it was presented, that its purpose was simply to group similar programs for logical and marketing reasons. We were never told that it was intended to help limit the number of courses a student could take.

But the result of it was that courses we thought of as natural families, for example courses that all have a studio component, suddenly had a limitation that made

it impossible for students to take some classes needed to complete a "track" of classes from beginning to advanced. We had sometimes created families from such sequences of courses only to discover that we had inadvertently blocked students from a logical progression of courses and topics.

Now those family definitions seem set in stone. But we must be allowed to revisit those based on their real use if we wish to allow our students the best sequencing of course content.

REPEATABILITY

Unlike some subjects where all faculty need to teach the same thing in pretty much the same way, (basic black and white photography or photo history as examples) some advanced creative subjects are different. For example, take the topic of lighting.

Every good photographer knows that it is the lighting that often separates out the very high-quality imagery from the general pack. But lighting is as much an art as any other technique. Different "masters" at lighting in both the still world and the motion world have not just different styles of light use but different approaches to teaching it.

In my case, I learned lighting from quite a number of sources, some of the most important coming from DPs (Directors of Photography) in the motion picture world. I believe that given the critical nature of a commercial photographer's ability to light their products, sets,

fashion, portrait sitters, etc. students need to study under more than one lighting instructor.

Among our faculty we have several photographers who are excellent at lighting but their work, as one would expect, is very different from one another because their styles and approaches to lighting are different. We often "checkerboard" those classes rotating instructors. I believe our students should be able to take classes from as many of them as they can, and that would include also taking the lighting course offered by RTV.

There are not many courses like that, but the really creative ones fit the model. Portraiture and fashion are perfect fits. And for that matter digital editing is as much an art form in and of itself as any other topic. I approach Photoshop very differently from a friend of mine who is a graphic designer and yet we have both learned a great deal from each other.

If our goal is to be the best, and that goal is supported by the administration, then this is clearly an area that should be addressed. Rather than competing with each other, that cross fertilization of inspiration and knowledge should be seen as very important team work.

By simply allowing repeatability we would be almost instantly increasing the quality of student learning. In normal environments it would be a no-brainer and a revenue source. However, as with returning professionals, here In the land of subsidized education, it is now a cost. When every student is a cost to the state it makes sense they want to get them in and out as quickly and cheaply as possible with student needs not part of the mix.

But a good solution is for the district or college to allow audits subject to faculty approval: it costs the school nothing sine facilities and instructor is already paid for, is free for the students, and requires no additional work by the faculty member unless they want to also grade or critique the work of the auditing students. Plus returning students can be used to help struggling beginners in the manner of TAs.

OUTREACH

A few years ago, Kevin Costner starred in a movie about a mid-western corn farmer and baseball fan who followed the directions of voices from his corn field to build a ball diamond there. They assured him that "If you build it, he will come."[41] It worked for him due to the magic of movie fantasy. In the real world, sadly, it has not worked for us.

We have designed, and the district has built, the best photo educational facilities in the state and some believe, in the country. 30,000 square feet of photo-educational facilities with state-of-the art studios and even three incredibly well equipped darkrooms. No one... NO ONE has facilities like ours in the state... and maybe in the country.

We built it, but they will not come *unless* they know it exists. And yet, to our surprise, we are still constantly

[41] *Universal Pictures "Field of Dreams" 1989 with Kevin Costner and James Earl Jones based on the novel, "Shoeless Joe" by W.P. Kinsella. The dream also worked for Don Lansing, the real land owner whose family property was used and is now a tourist site.*

running into people in the regional photo world who do NOT know it exists.

We built it but they will not come in the onrushing world of the internet and virtually self-driving cameras unless we can show them that by coming and studying with us we can provide them with an education better than they can get online for free.

We built it but they will not come in a world inundated with entertaining magnets for their attention designed specifically for that demographic unless our messages and promotions can compete on that same level.

In short if we rely on the old world's model where potential students already knew from common social messaging that brick and mortar education was vital for success, we will fail because those old voices are becoming silent and that old model is falling into disrespect. Traditionally there was little if any competition for our services; up until the very early 2000s there was no one that could seriously compete with the professional photography program at San Diego City College. And that allowed us to get a bit complacent.

All that was made worse when in the mid 2000s budgets were cut so far and so deep into our program that the truth was, despite the facilities, we were reduced to a gutted program offering little better than some of the other programs in the area. Despite district claims a couple of years ago of bringing course levels back, to the contrary, our program is still not allowed to come back and offer the full course load we were doing 8-10 years ago.

Well, to the surprise of no one paying attention to such things, the demographic of our potential students got the message: "City College is no longer in the game." They may have a fancy building (for those few who knew even that) but they are no longer offering the full-on professional catalog of courses. Word got out and it was not a good word. So they did the logical thing: they stopped looking at us and started looking elsewhere.

Every year I give workshops at the San Diego/Del Mar Fair and do judging and presentation for photography and photoshop groups to help spread the word. It is so distressing to hear someone come up to me afterward and ask, "What happened to City College? They used to be the best around..."

The only voice many of them will hear promoting the value of what we offer is ours. If we do not use it, we will fail. This is the age of success going to the squeakiest, flashiest of wheels. Resting on laurels and historical wishful thinking is guaranteed to see us fail.

But we've let it go way too far and now replacing the competitive voices and calls for their attention in this internet/WiFi world has a budgetary component. We are already in economic jeopardy and under our current system do not have the resources for the required outreach. Our needs in this vocational arena are very different than for those arenas in traditional academics and if the current trend continues we will fall farther and farther behind the attention of the State and District.

So we will have to find internal resources and means to create those outreach programs and the district and

college will have to work with us to let us create our own promotions if they will not or cannot create them for us. We have the internal skills to produce such outreach materials but not the time.

We also need to realize that in specialty and niche programs such as ours, two additional factors impact enrollment. One is the traditional idea that students interested in community colleges simply and nearly automatically attend the closest one. That is simply not true anymore, especially in a mobile environment such as southern California. We have a number of students who live much closer to other Community Colleges offering photo courses but who make the effort to come to our program because they consider it to be a better program.

A second issue for niche programs is local saturation. Almost EVERY potential student in a district needs the GE courses but only a limited number want or need specialty classes such as our photo program offers.

That means we need to cast our net much farther afield. If we can start to attract out-of-state students, their increased fees go a long way to helping the financial situation. And that becomes symbiotic as they help, both directly and indirectly, to increase our exposure and reputation.

But that too requires some serious outreach, or in the parlance, marketing and advertising. We have the in-program talent to do that sort of thing. But with the increasing load of administrative duties, we simply do not have the time nor do we have the money to do it on an out-of-pocket basis.

That type of activity was never something also required of faculty. But from a perspective of pure self-interest in keeping and doing our jobs, we have little choice but to figure it out for ourselves and make it happen. But we will need help even if it is in something as simple as release time, we simply cannot do it alone and under the normal systematic approach.

IMAGE-MAKING PROGRAM STRUCTURE

This is highly unlikely to happen but because it works so well in a few of the more famous schools is worth mentioning as an ideal. In those places, such as the New York Film Academy, all of the image-making topics related to photo/optical capture are presented in a more integrated, cooperative, and symbiotic relationship vis-à-vis the overall program structure. Instead of competitive fiefdoms they are seen as various forms of a similar art/craft continuum.

At NYFA, still photography, filmmaking, animation, graphic arts, all have their own "tracks" for emphasis but are integrated as much as possible to take advantage of the mutually fundamental concepts. The materiel, concepts, equipment that is used mutually by various artists and craftspeople are presented in courses for all of those effected by the topic. The result is a much higher degree of mutual respect, skill reinforcement, cooperation, cross-fertilization, and enhanced learning for the students.

At San Diego City College, on the other hand, we've evolved our current programs from more competitive roots. RTV, Graphic Arts, Photography are all

established independent programs which seem to each to be competing for students. We do not have serious filmmaking per se though it is skirted around in RTV; we do not have documentary per se though it too is skimmed over in RTV and Photojournalism; we do not have corporate/industrial/commercial film and video making programs though the concepts are more closely aligned with the business and advertising models currently part of the still photography program.

The problem is that the current model both facilitates and perpetuates old fiefdom perspectives and siege mentalities in which some think that a single domain can own a single process. The results of such thinking are dysfunctional and counter-productive.

Instead of building on each other's' strengths we hide in our little caves trying to protect turf that was never really ours alone anyway. That resulting "us vs. them" perspective is fueled to even greater heat because, as noted above, the economy is resulting in greater competition for decreasing enrollment. Programs and courses are being cut and others put in serious jeopardy. Few things better create faculty paranoia and wall building competition than loss of courses.

But it is competition based on a false premise and it leads, not to solutions, but to greater losses for all of us. And that desperation leads to irrational positions... and that feeds the inter-program animosity and ill will. We are stuck in a self-defeating, counter-productive, death spiral and it needs to end with a review of how to properly bring these disciplines into the synchronization and cooperation they need and deserve.

No one, for example, owns the concept of motion any more than the idea that photography owns the idea of optical based capture (which would mean that we would also own filmmaking in its entirety). If motion were the sole domain of RTV then graphic arts could not be offering animation. No one owns drawing or painting even those cross arbitrary fine art and graphic art boundaries as the needs of the final image dictate.

That photography crosses art and graphic art lines is clear and accepted and no one in Graphic arts complains when we teach composition and they are even willing to cooperate when we send our students to take drawing and Two-Dimensional Design courses. That it crosses chemistry lines has been accepted for years. It also crosses lines with physics, both Newtonian and Quantum Mechanics, in the areas of optics and a need to understand how light – photons – work and can be controlled to make our images. That it crosses computer science lines in the era of digital photography is finally accepted. That it crosses marketing lines with very specific marketing needs for selling creative services and products has been grudgingly conceded more recently.

In many of those cases, following angst-laden fits of pouting and stamping of tiny feet, and some occasional irrational pushback, photo programs have managed to incorporate specific parts of those processes into their educational programs. And to the amazement of those protesting such inclusion, the sun remained fixed in orbit and darkness did not descend over the face of the earth or even their little corner of it.

The bottom line, not just for photo programs but for many programs entering this complex and dangerous new world is this:

No longer does any single domain own any single process!

Now professional still photography is crossing the line with motion capture and, as has happened with the other crossings there is the typical pushback from threatened domains of filmmaking and broadcast programs.

As that line blurs, as it certainly is going to, instead of seeing an incredible opportunity to develop a new track where the processes of motion capture are melded with the processes of commercial photo marketing needs, they see only competition for enrollment when, in fact, students for such a new track and students for their traditional worlds are not the same.

The problem is, as our disciplines merge more and more, those processes are increasingly operational across older traditional academic boundaries even though economic and business needs have, in the real world, crossed those boundaries long ago.

The world into which we are evolving is seeing a much higher degree of integration between these fields as the distribution and display potentials of the internet and World Wide Web introduce newcomers to possibilities for audiences and viewers that never existed even 5 years ago and the equipment-based "buy-in" costs keep dropping.

Our existing model is still based on a working model of the image-making world that existed for nearly 100 years but is fast disappearing. It fosters competitiveness, antagonism, and is counter to the way the real world of image making and image disseminating is rapidly evolving.

The successful professional photographer in the near future is going to have to be far more than just a "photographer." They are going to need to be able to provide a "concept-to-completion" package of creative services to corporate and industrial clients that meet ALL of those clients' needs from a one-stop-shopping business model. I believe the best "photo" programs of the future will all adopt this integration and, if necessary, restructure and/or draw from existing programs to reflect this new world.

To properly prepare students for such a world may require a significant restructuring of not just specific course offerings but how a given school thinks about the program and material to be provided... and how to provide it. That restructuring will require drawing on materials from a number of existing fields in addition to creating some brand-new courses. Here is but one possible view of the integration that will be required.

In the center is the new program (I've given it a working title of "Professional Creative Service" but that's just to give it some label); arranged around it are existing programs and topics that will need to provide material for that new program to make graduating students competitive.

This does not include some topics involving human perception that would come from the psychology realm or the legal issues discussed above.

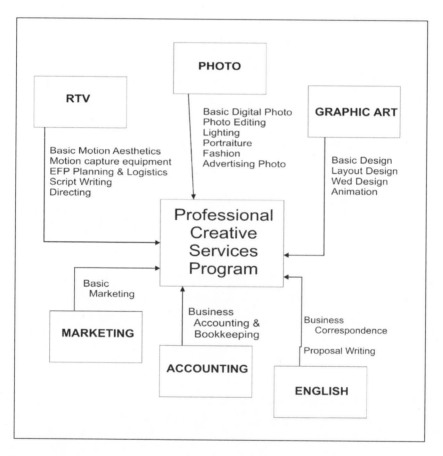

How all these topics would be finally integrated and sequenced is not the objective of this document. One option. However, would be to make these courses so that they provide credits to both their own majors and also to this new one. Perhaps some need to be integrated into the new program so they are taught from that perspective to be relevant.

But what should clear by now is that some restructuring and integration of materials along this model is a necessary discussion topic for both administration and faculty wherever the topics in the diagram are taught. We should be thinking openly about doing that very thing ourselves.

It is also probably way past time that the college needs to rethink the internal "school" structure here. Currently both visual and performing arts (a wild enough mix all by itself) are combined with other "humanities" programs including languages, philosophy, history, and identify programs into a single school. Those programs and ours represent about as broad a litany of competing types of educational and logistical needs as is possible to consider.

No one person could reasonably try to understand, much less oversee all of those competing needs. This is not a shot at the current Dean trying to oversee all of this and no disrespect is intended. Indeed, her job is truly like trying to herd cats; simultaneously juggling stable subjects that rarely change with unstable ones that are in constant change like ours, each pulling in their own, sometimes conflicting directions for everything from finances to personnel, made even more complex by competing and psychologically different personalities endemic to those subjects.

No one could legitimately hold that the needs and personalities of theater, dance, graphic arts, fine arts, music, and photo programs are the same much less even similar to the needs of language or history courses.

The result of that need to deal with competing mentalities and educational needs is an overly complex, virtually schizophrenic situation not fair to any Dean and not workable for the disparate departments and programs in that school.

The visual arts programs need to be contained in their own school with its own Dean who is drawn from that world and understands the real-world environment in which those subjects operate.

The Dean for this newly combined set of programs should be sufficiently versed in that world to see the material in this paper as old news and already be planning how to address it moving forward. It is simply asking too much of any individual, already overwhelmed by the chaos of our conflicting departments and programs, to also now calmly and objectively address a potential program restructuring of the magnitude suggested here.

So where does all of this lead us... or leave us?

FINAL THOUGHTS

"The Measure of intelligence is the ability to change"
(Albert Einstein)

This discussion has revealed some amazing technological inventions that are being worked on right now that will have a major disruptive effect on the status quo in the world of professional photography and therefore in the world of education that concerns itself with professional photography.

Which of those technologies will make it into consumer hands in the next 2, 5, or 10 years is prophetical guessing. As we noted at the very first, the future isn't always what we thought it would be. And, anyway, why the fuss, why rock the boat? Most students seem to be happy and satisfied. We seem to be stumbling along more or less OK?

Or are we?

Will Rogers once said, "Even if you are on the right track, if you just sit there you will get run over." Success in this storm-tossed environment is being able to stay afloat on the next wave of change; but there is no lookout in the crow's nest, we haven't even handed out the life vests and, to complete the metaphor, in my opinion what little we are doing is simply rearranging the deck chairs on the Titanic.

Some changes flowing from inventions just now hitting "the streets" are already in evidence. Quantum computers are now operational in the lab. And yet the trend toward homogenized mediocrity in professional imagery is in evidence and a subject of comment and concern among a large portion of the professional community. Another simple question arises: do we in academia continue to support that creatively retrograde movement or do we do all we can to try to push back against it?

Finger pointing is less than helpful as fingers are pointed in all directions attempting to find a source to blame. And they may all be right... or none of them may be.

The most common blame however is attached to this new technology including the internet, social media, and the use of AI concepts allowing the camera to become self-driving and less and less requiring of human input. A significant number of these doomsayers insist that this new technology inherently predicates this descent into mediocrity and therefore irrelevancy.

I strongly disagree.

It is undeniable that some of this technology *allows* that lowered standard of excellence; I do not, however, think that it either *creates* it or demands it.

What creates it is laziness in thinking, effort, and education. Critical thinking and insightful discrimination of quality results are no less critical in the visual arts than they are in mathematics. To me, the new technology as readily creates the potential for exciting new creative expression on a revolutionary

scale... but only for those who have soldiered through the doldrums and are ready to use it.

Technology holds the promise of unprecedented freedom and amazing options. But before we get giddy over the future, and pin our hopes on every new idea to form a dissertation and then be foisted down on us, it may be a proper time to re-read the story of Icarus.

It is clear to me that the deciding factor will be education. When, as noted above, simple human competitiveness and acquisitive tendencies start to feel the compulsion to rise above the crowd and ask for the tools and resources to do that, who will be there to even hear that call, much less to answer it?

I can answer that. Only those whose education has prepared them for it.

And that, if we want to call ourselves teachers or educators, is our job, our calling, and will be our legacy... whether we have risen to that occasion, or not.

In the end it comes down to the teacher in the classroom. But those teachers, in a world where technology is the prime mover, cannot do it with data and good intentions alone.

They will require the support of their institutions and the state's systems that drive them. Remember "The Calf Path?" In the end it is not the laborers building roads who, important as they are, make policy. The decision as to whether to continue wobbling down our own calf path or to build a new, straight, highway lies in the hands of administrators and *their* vision for the future.

I understand, as noted before, that making the program the best, may result in it being one of the hardest and that, in the short term, that may see a drop in enrollment as there is some current "weeding out" while the reputation re-builds and spreads. But in our favor is the realization that people – students - who wish to attain the highest results in education are not drawn to the easiest but to the best.

Students are not attracted to Art Center or RIT or the New York Film Academy because they are easy or cheap. Harvard and Yale do not attract students because they are easy or cheap. The state is full of options that are relatively easy and most of them are comparatively cheap. We don't need another one.

But the state is not full of options that are devoted to being the best, period. Even in our case, some thought that assertion only meant we wanted to just be better than other local, regional programs, i.e. a matter of comparisons. But that was not the intent at all. The intent was to be the best it was possible to be. That is a very different goal.

We worked very hard to reach that goal and managed, in the process, to create a program drawing praise and envy from all over the country. Now we are fighting equally hard to save it.

Which would we rather be? If we chose the high road then I think as word spreads and the field gets tougher, we will see a significant rise in enrollment if we are willing to work toward that high bar and willing to be patient in the "building" Stage. The problem with setting low expectations and lowered goals is that they

are easy to hit and once attained, tend to revert from a goal into a shackle. And in th end students will desert us seeing us as offering no more than YouTube tutorials.

By comparison, the nice thing about aiming to be the best is that it is a goal easy to continually elevate. Shooting that high is hard but exhilarating. Shooting lower is an easy target rife with complacency and, in the end, program irrelevance.

So this has been my personal attempt to shake up the complacency and try to start a dialogue, sometimes purposefully with hard edged and pointed verbiage not designed to skirt politely around delicate subjects but to tackle them head on in a verbal slap in the face to get the attention this topic needs and deserves if our incredible program is to survive.

The ideas and conclusions here are my own and some of the material is based solely on the specifics of my own school. I do think, however, that the general material and conclusion applies to all of those in professional photography education. And I think the problems will, when they hit, effect all of the educational world.

Sadly, not one of us knows all there is to know on the subject (or ANY subject for that matter). Despite how we would like to think of ourselves, none of us has a claim to omniscience or, in our case, photographic divinity.

Moreover, in a discussion as wide ranging as this, with influences so far flung, it cannot be doubted that other minds have seen all those dots and perhaps some more as well, but connected them in a different pattern and arrived at a different set of conclusions. I am not a

soothsayer or oracle but, nevertheless, to me the writing on this wall is decoded and clear.

And we in education face a question of critical proportions perhaps more serious and meaningful than any we have ever faced before. In a near-future world where huge percentages of able individuals may have no way to make a living because there ARE no jobs for them, how do we try to make sure that it is OUR students who can fit in and obtain one of those few remaining positions? Because – and here may be the most important question of all -- if we cannot do that, then of what value are we?

People and systems, bound by entropy into their current paths or even those in stasis, change only when the pain of the status quo is greater than the pain of venturing off into that uncharted and dangerous territory. That territory waiting for us and our students just down the track redefines a label of uncharted and dangerous.

In the Second Machine Age world where machines can not only outperform us physically as they did in the first Machine Age – the industrial revolution – but can also outperform us intellectually, plus are faster and less prone to error, and in the end a better, cheaper, more durable, and less contentious choice as workers than most of their human counterparts, what role will image making play?

What, specifically, do we as educators in an image making discipline need to learn and change to prepare our students for those days that will almost certainly happen in their lifetimes? And what do our sister disciplines need to do if we are to be able to identify

those areas of innovative cooperation we will need to create new courses, programs, tracks, *whatever*, that will allow all of our students a better chance at success as the world of useful employees shrinks unimaginably.

If this surface examination of influences has yielded no other insight it must at least have suggested this: our discipline of professional photography, and, I believe, virtually all disciplines of our near future, no longer can be seen as existing in a vacuum. Photography clearly crosses many disciplinary lines already. But with influences on education coming from all quarters, that is equally true of others as well.

If we insist on maintaining that competitive model vis-à-vis various programs and disciplines, then we will only doom us all. If we do not put aside our petty rivalries so that, together we can prepare our students to better operate and succeed in that competitive world awaiting them, then we will have failed them all and need to turn in our "Educator" badges.

To borrow a quip from Benjamin Franklin at the signing of the Declaration of Independence when contemplating the potential turmoil they knew they were unleashing, "If we do not hang together we shall assuredly all hang separately.[42]" It is not an altogether positive thing to realize, down the road, we may have escaped hanging, but it was only because there was no one left who knew how to tie a knot.

If we think and admit that the world of professional photography is competitive now, then in that apocalyptic new age headed our way we can only surmise that "We

[42] *A nearly identical quote is also ascribed to Thomas Paine.*

ain't seen nothin' yet!" So do we, as educators, step up to the plate, try to accommodate our teaching to preparing students for this new world?

Or do we simply throw up our hands, wrap ourselves in the warm blanket of the normalcy effect, admit we're not up to the task (or deny, as many will up until the dam breaks, that it is not really going to happen at all), and, when it does, let students fend for themselves while we go off in a corner and whine about the complete unfairness of this new world for which we did nothing to prepare them?

A larger question for education generally is the same one: what will need to be changed in terms of material, approach, philosophy... whatever... to turn out students with a better chance of success in that new world as opposed to becoming just another human drone in what Harari called "The Useless Class" of people?

In the Guardian article mentioned earlier[43], and in his book "A Brief History of Tomorrow," Harari suggests that in a post-work world of about 2050 AD, contentment (and control) of the non-working class will come through the creation of artificial stimulation created by highly creative and imaginative makers of imagery and virtual reality games.

Remember, this view of the near future is not some dystopian nightmare of a drug addled science fiction author, it resonates with a growing consensus of scientists from all branches including Stephen Hawking and Bill Gates. And if even a fraction of it is an accurate

[43] *https://www.theguardian.com/technology/2017/may/08/virtual-reality-religion-robots-sapiens-book*

prediction of what happens as algorithms increasingly perform jobs better than humans, then who better to be in a good position when it happens than those trained specifically in creative services, image making, and imaginative enterprises – those things computers *can't* do?

But there remains a wild card I have consciously avoided but there is no way to claim a broad coverage of influences without at least mentioning it. And that is politics.

It would be disingenuous for anyone to claim that academia has not become increasingly politicized. We've spent our time looking mostly at where technology is likely taking us. That is fine for the world of professional photography, but in truth, the educational system is far more prone to vulnerability in the face of political-ideological influences. And that presents a problem for our ability to see the future.

In his new book "The Future of War: A History" author George Freedman (Professor emeritus of war studies at Kings College, London) makes a statement directly to our point. He asserts that technology is far easier to predict than politics. He is writing about geo-political conflict but it is as applicable in our world as well.

Out in the real world, technology and its value to people is far more of a driving force than it has ever been in the safe and often intellectually isolated walls of academia. In some important ways that is precisely why many of the problems I've mentioned are at play right now.

There has always been a conflict when ideology impacts reality. For reasons unclear to me but perhaps best

explained by the Huxley quote used earlier to the effect that we humans tend to believe what we tend to prefer, buckets of intellectual blood is drawn constantly between parties, one of whom looks fondly back on a world that never actually existed and the other looks forward to a world that has failed every time it was tried. Reality seems to play no part in those debates.

Here in academia we are seeing a similar debate over ideologically based solutions to a problem everyone admits exists – the slide of academic rankings. But reality has no place at that table either.

While it is amusing to watch as an outsider, now in the midst of it, trying to prepare students to face not some ideologically fabricated world that may or may not ever exist and work, we in vocational programs such a professional photography, are tasked with preparing them to go out into that *real* world for which that ideological debate is largely irrelevant. That is not amusing, it is maddening.

So, we as educators in the photo world have some hard decisions and even harder adjustments to make to remain viable over the next 5, 10, 15 years ahead. But since we can't do it unilaterally while in the confines of a larger system, so does the whole educational system from the Feds, to the State, and right down to the District and College levels.

I think that none of us at any level can do this alone; it must be a concerted, comprehensive approach with a lot of pain – emotionally, intellectually, and certainly financially – to go around. Given the general gridlock on

nearly all authoritative levels it may be that such change is impossible. If that is true then we are all lost.

It cannot start, for sure, while folks in government or even just in their competing educational fiefdoms continue to embrace the siege mentality. We have to come out from behind our battlements and start talking about it, even when it hurts. Because if we let our program, much less the broader educational system, be overwhelmed by the unstoppable future and fail, it is going to hurt us all a whole lot more than an occasionally squashed toe or bruised ego in a heated debate.

If this paper can do no more than to help start that discussion, and start it quickly, then the effort will have been worth it and this will have been a towering success.

THE FUTURE OF PHOTOGRAPHY & PHOTO EDUCATION

ADDENDUM: About the Author

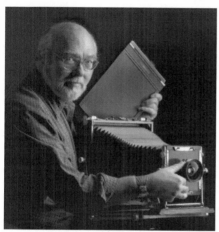

2 *Photo (c) Scott Golia*

David King has drawn and painted and taken pictures since grade school. In High School he was awarded an Art Scholarship to Missouri State University, at Warrensburg. Instead, he went to work for Hallmark Cards as an engraver and attended classes at the famous Kansas City Art institute. He attended The University of Denver (double major in Fine Art and Philosophy) and Colorado State University (Graphic Art) and developed an interest in photography. He returned to the University of Denver, following 4 yrs with AIS (Army Intelligence and Security) and 3 yrs of Law School in San Diego, CA to work on an MFA in printmaking,

He returned to the world of photography and was co-owner of "**The Darkroom**," a combination rental lab, school of photography (26 courses/22 instructors) and gallery (the first in Denver to show the works of Brett Weston and Morley Baer). Through the auspices of The Darkroom he produced product photography and editorial portraiture and also conducted photography and outdoor survival workshops into the Colorado Mountain Back Country. Since then he has continued to be involved in professional photography as well film and video production, including a few years (1982 - 1984) working first as an Art Director and then Creative Director for an ad agency in Denver.

His work has won numerous awards, including an Emmy nomination as producer for an anti-gang music video. His documentary and lyric outdoor images in still photography have been featured in regional and national magazines and his work among the northern New Mexico Pueblos was the subject of a PM Magazine featured TV segment. That project, "**TEWA**," on the Tewa-speaking Pueblos of New Mexico is in

the permanent collection of Mesa Verde National Monument and frequently travels throughout the country. A collection of portraits of Denver's **"Movers and Shakers"** was commissioned by and featured at the Colorado Celebration of the Arts. His work has been exhibited in galleries and private collections around the country.

In addition he produced the images for the pictorial book *Santa Fe, The City Different* and wrote the books *Thinking Digitally* and *Practical 3D Photography* for students of photography. In 2016 he provided the portraiture for "Voices: Honoring Veterans" available here: http://www.blurb.com/books/6706383-voices-honoring-veterans

David's still work specializing in editorial portraiture and commercial products and his video/film documentaries and music videos, and his award-winning industrial film/video production work has been produced for clients in such wide-ranging industries as corporate, heavy industry, oil and gas, mining, telecommunications, martial arts, law enforcement, education/training, and recreation. He received a **ISPI National Award of Excellence** for his training video work. A documentary video on street gangs done for the Denver Police Department (**"War on the Streets"**) received acclaim from police and communities around the country as one of the best programs on the subject produced to that date (1989).

He has produced film and video programs ranging from short music videos to longer documentary and industrial programs of up to sixty minutes. David wrote, produced, and directed the western music video *"Through The Gap"* starring Bruce Boxleitner and Martin Kove. He wrote, produced, and co-directed a screenplay adaptation for the short feature "*Handler*" (based on a segment from the Jane Martin play, "Talking With").

He produced a family adventure feature titled *Moosie* that is now being distributed and is available online through Netflix. *Moosie* won a **Videographer Award of Excellence**, an **AXIEM Silver Award** for Absolute Excellence In Electronic Media, and a **Silver Telly**, plus it has been awarded the **Dove Seal of Approval** for Family Programming.

Continuing through it all to produce still photography, he brought with him lighting and staging expertise honed with the film and video production work. David has been teaching Professional Photography

214

as well as Film and Video Production since the late 1970s in California and Colorado.

In January 2000 he returned to San Diego and taught as an adjunct professor of photography at San Diego City College and at Palomar College in San Marcos, CA. In December 2004 he was hired full time and is now a full Professor of Photography at San Diego City College. He also conducts workshops and seminars on various areas of photography, digital photography, and film/video production.

3 Photo (c) Jim Blase

In addition to teaching, David has been a judge at the famous International Photography Exhibition at the San Diego County (Del Mar) Fair since 2000 and is a returning member of the "Digital Dialog" panel of experts in digital photography featured each year during the exhibition. He is an invited panelist for a planned new presentation (2018) on the future of photography.